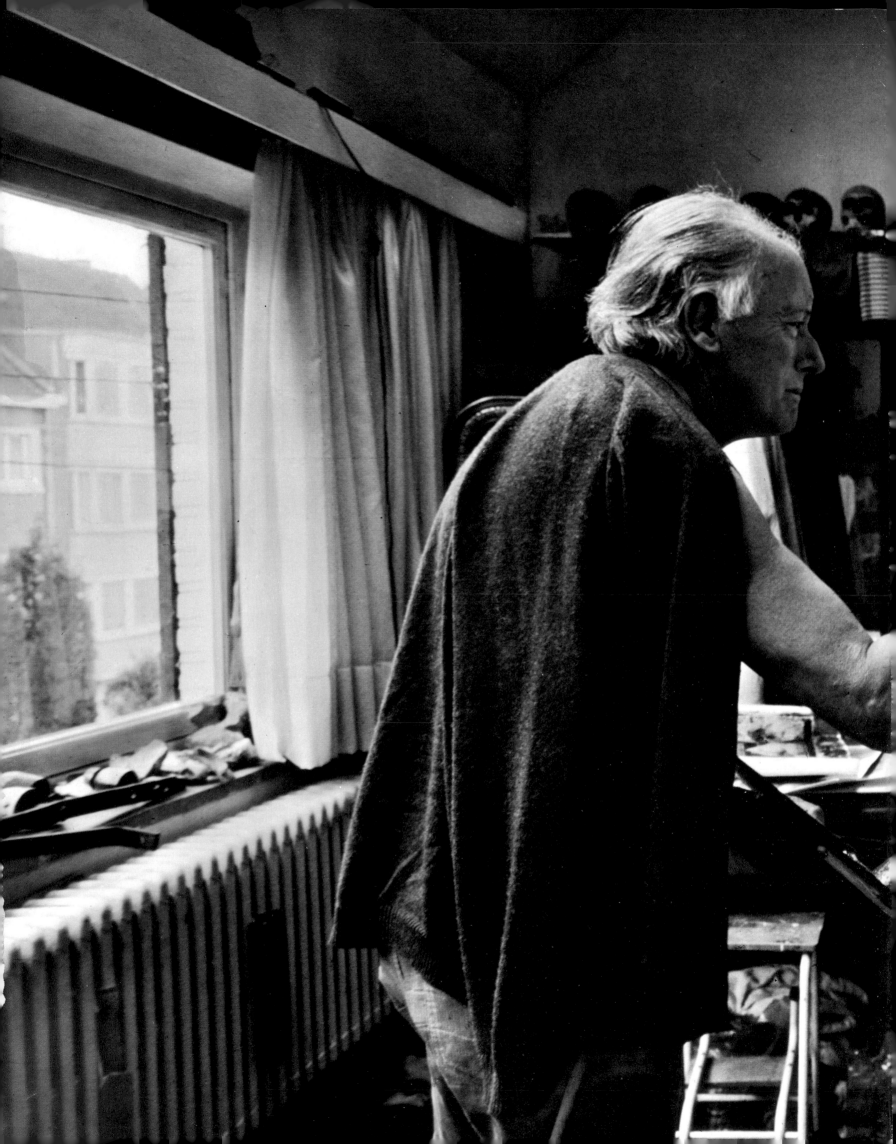

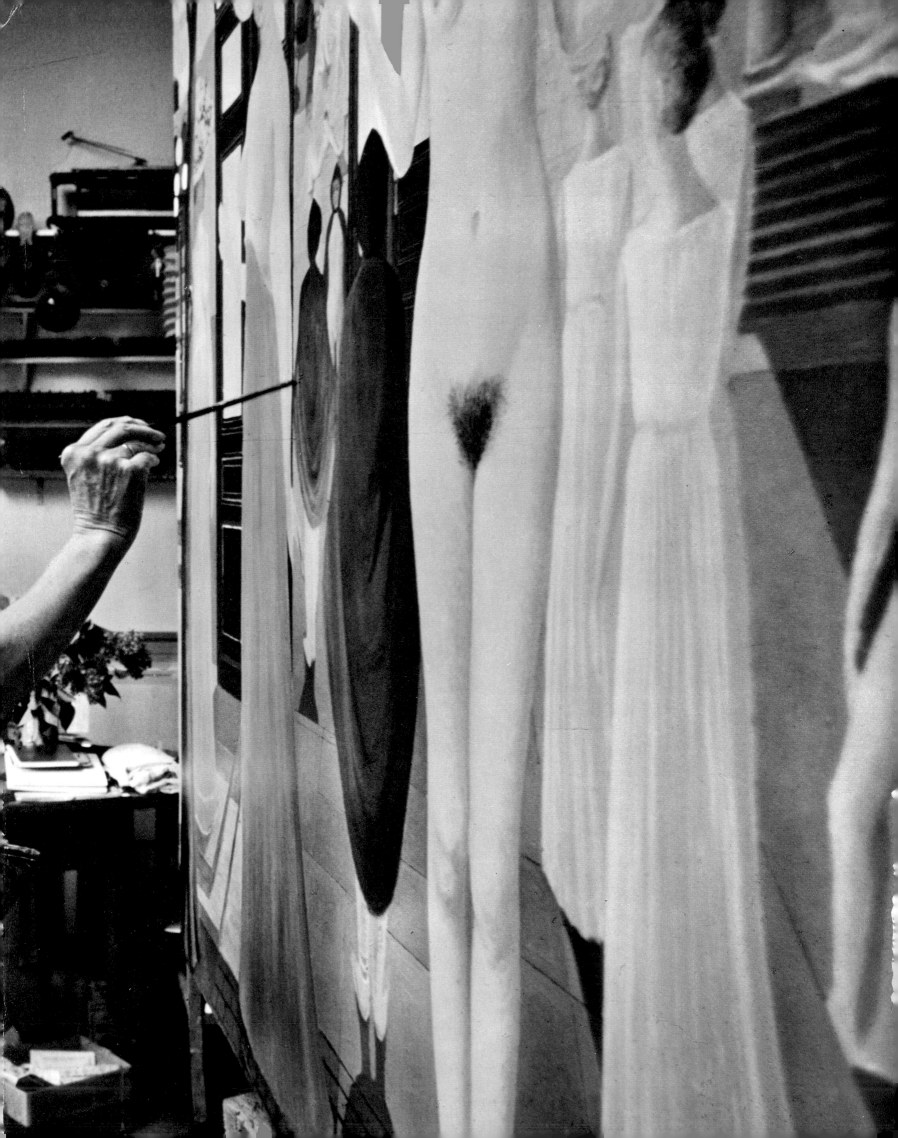

Conceived by Jean Saucet
Text by Antoine Terrasse
Translated from the French by Eleanor Levieux

PAUL DELVAUX

© 1973 E.P.I., Editions Filipacchi, 65, av. des Champs-Elysées, 75008 Paris.
English text © by J. Philip O'Hara, Inc.

All rights reserved. Nothing herein may be reproduced in any form without
written permission from the publisher. Manufactured in France by Humblot, Nancy.

J. Philip O'Hara, Inc., 20 East Huron, Chicago 60611. Published simultaneously
in Canada by Van Nostrand Reinhold Ltd., Scarborough, Ontario.

Library of Congress Catalogue Card Number: 72-13195

ISBN: 0-87955-604-8

First Printing E

A Howard Greenfeld Book
J. PHILIP O'HARA

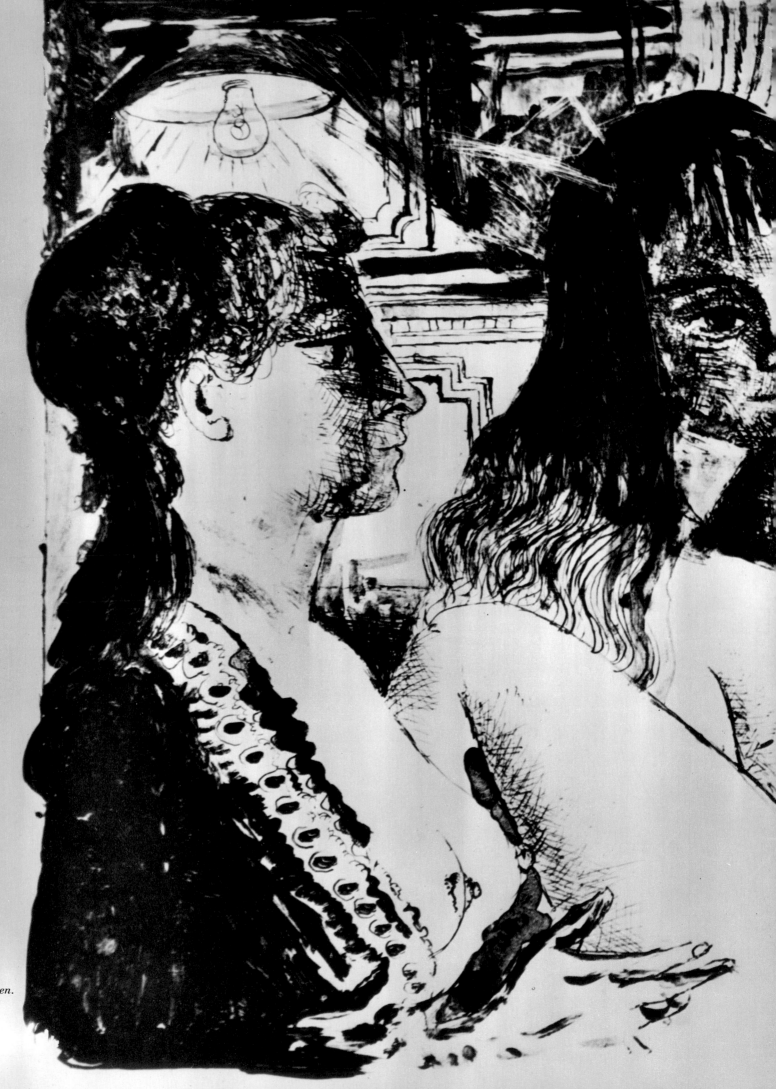

The three women.
1967.
Original
Lithograph.
21.4 × 29.8

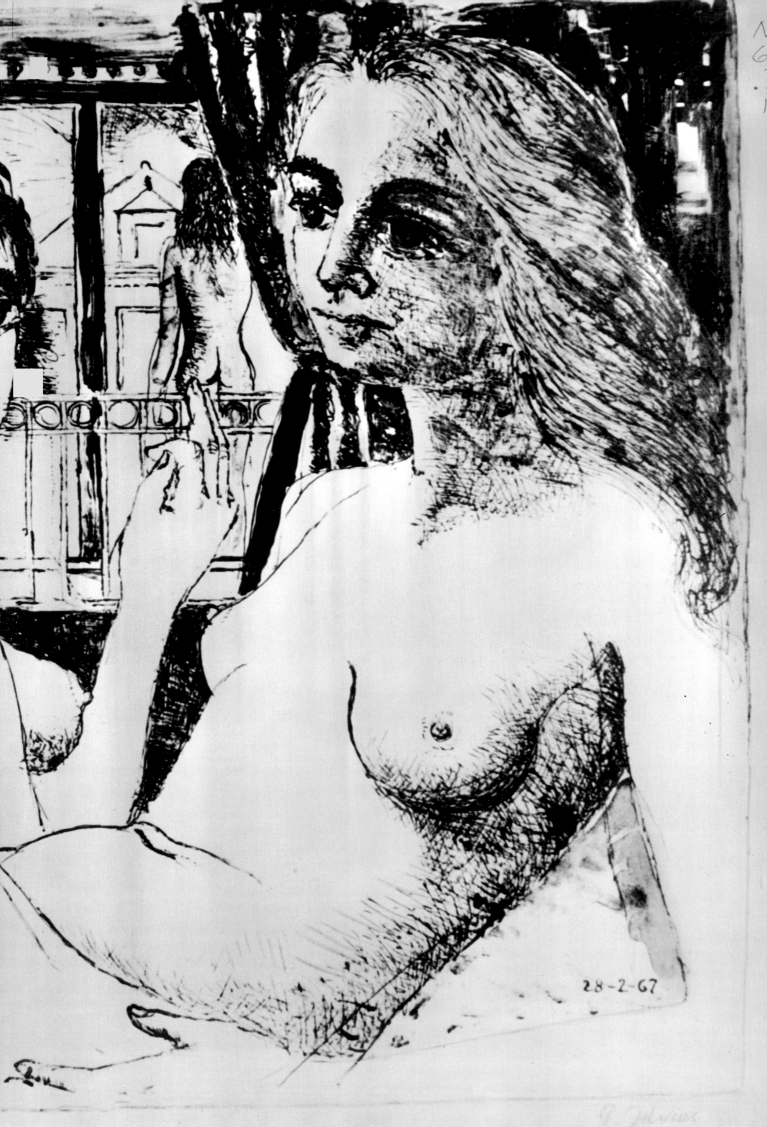

28-2-67

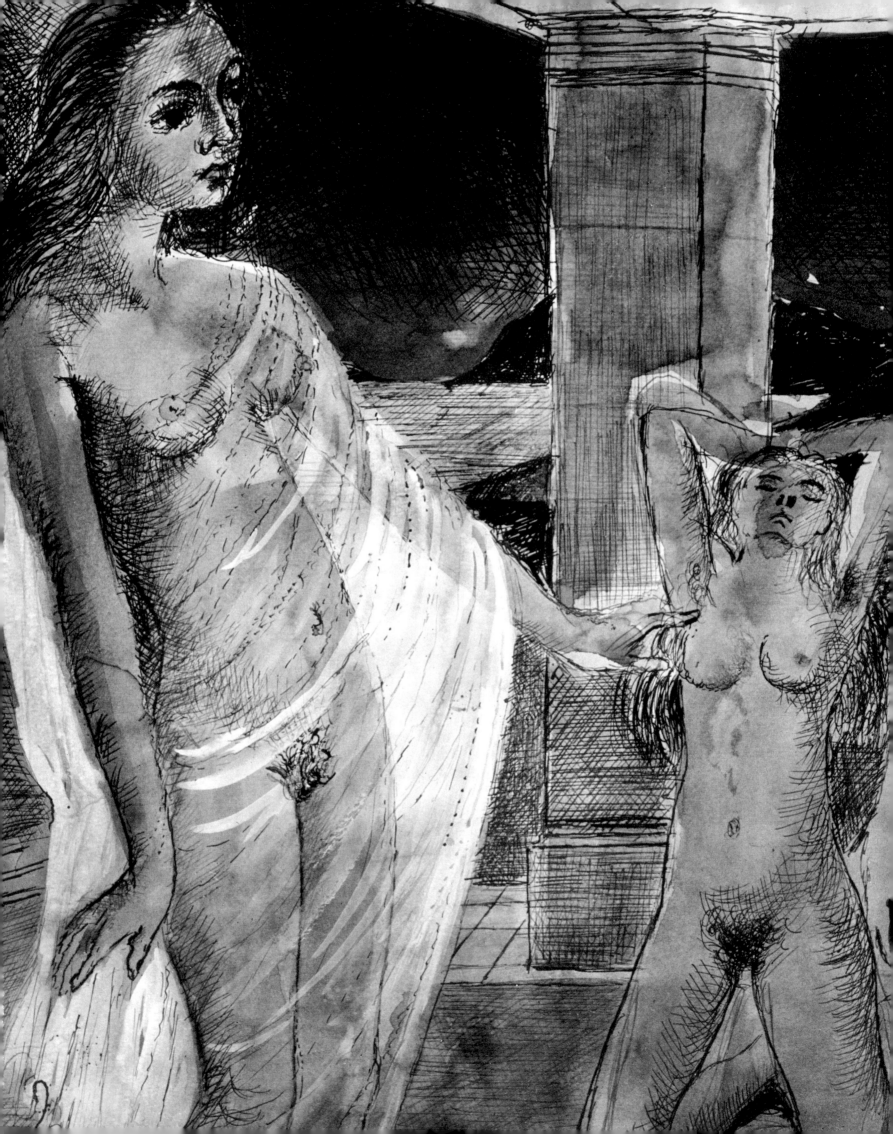

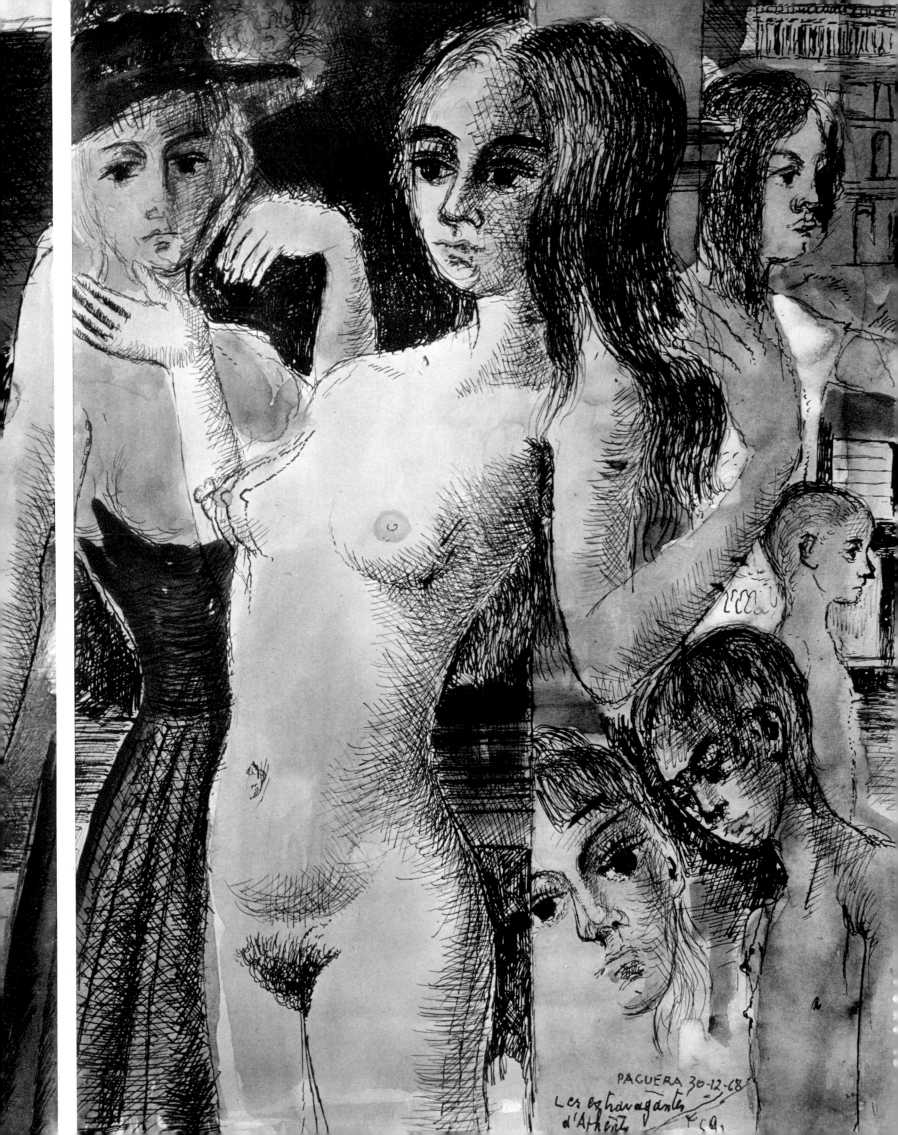

PACUERA 30-12-68
Les extravagantes
d'Athènes

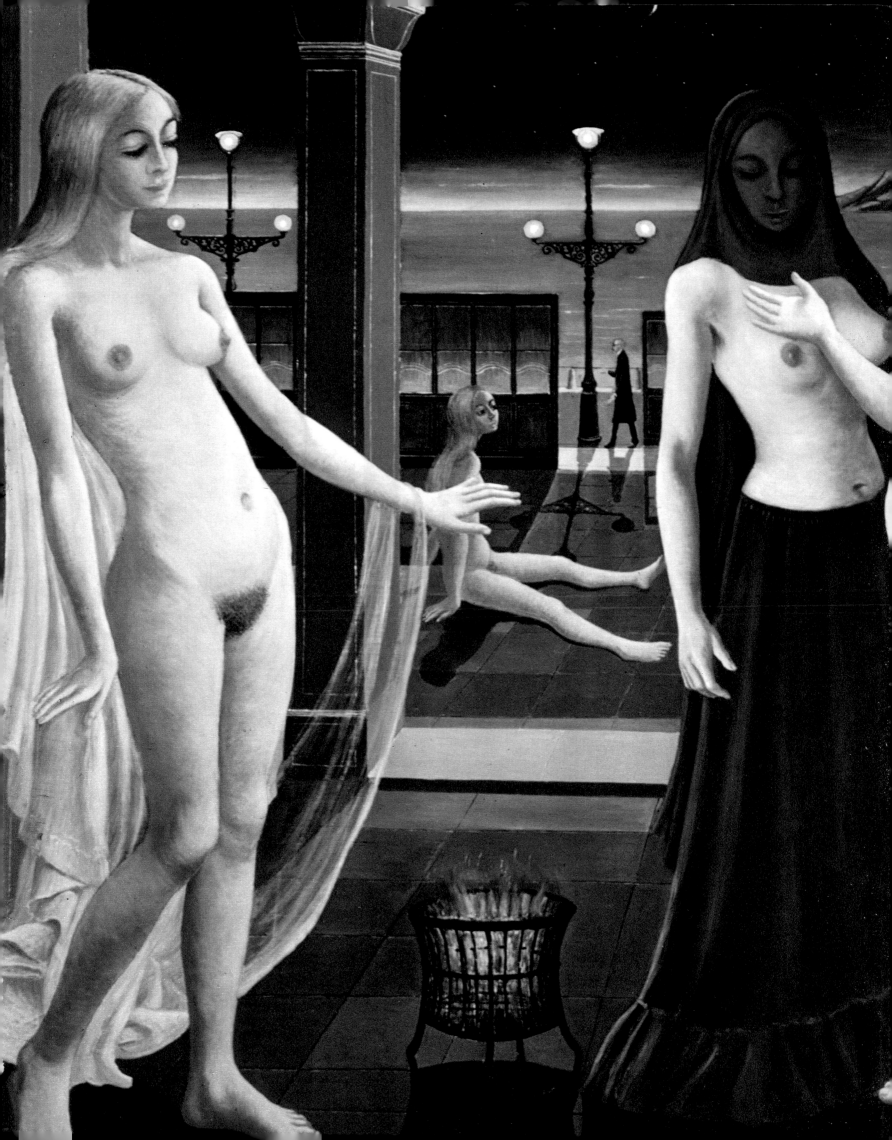

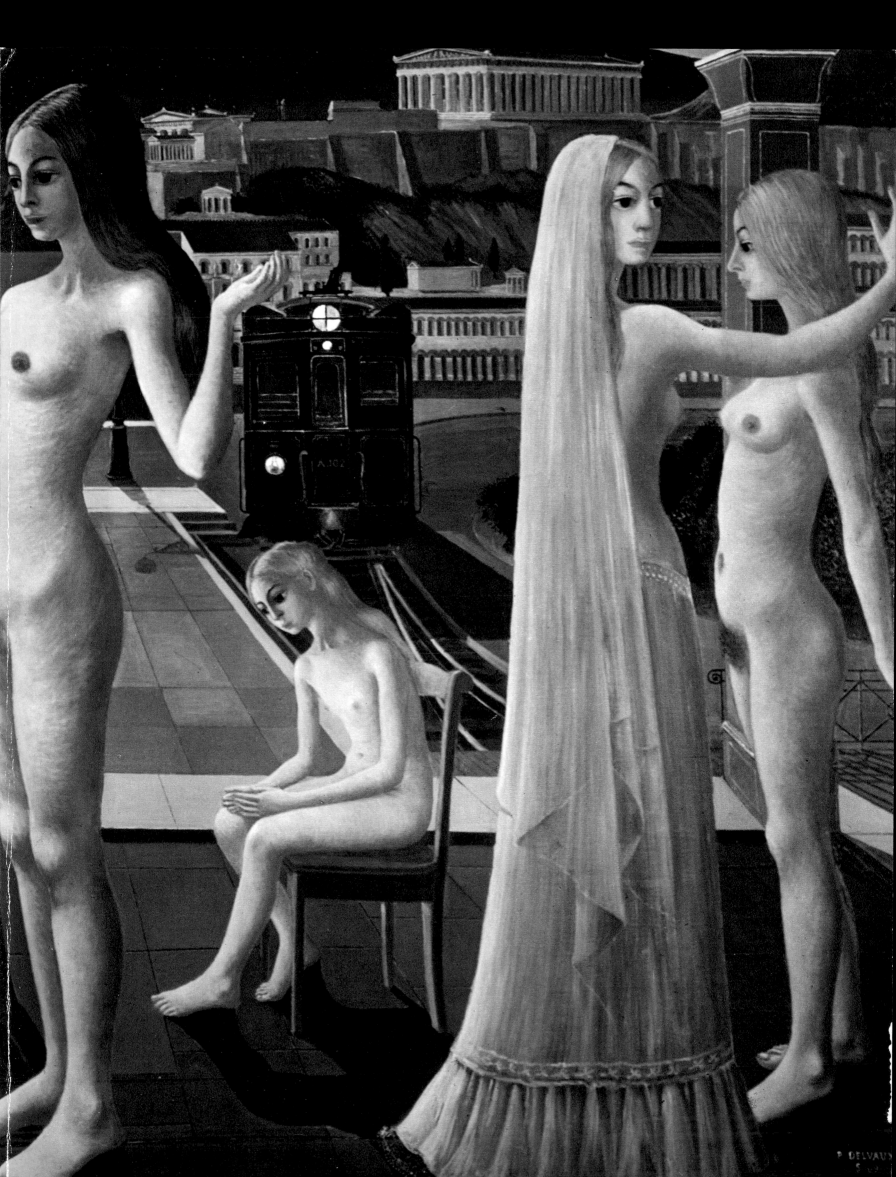

EXPRESSING THE CLIMATE,

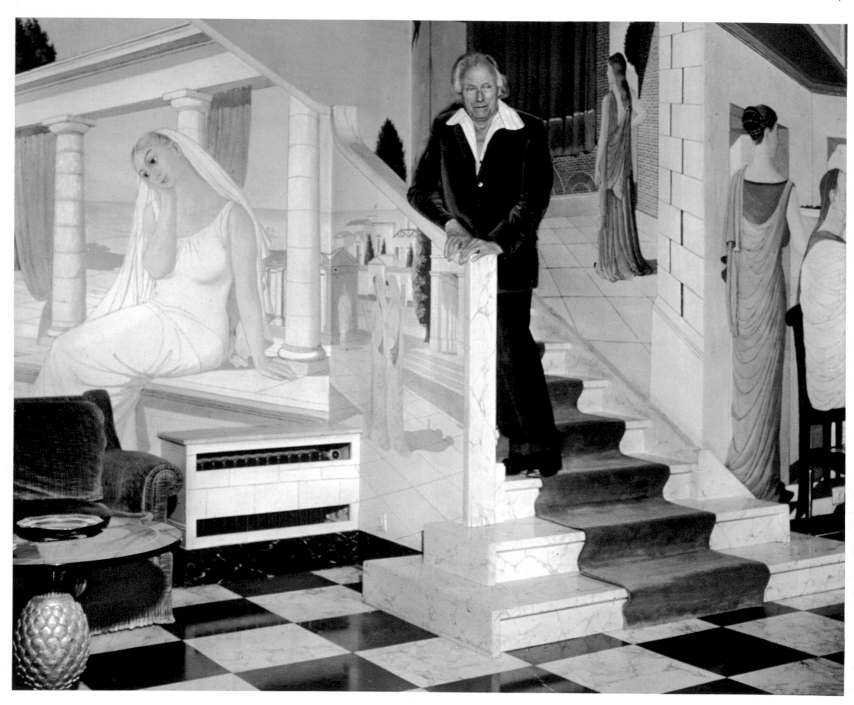

Preceding double pages:
Watercolor studies for "Les extravagantes d'Athènes."
Les extravagantes d'Athènes . 1969 . 72 × 104

Above:
Paul Delvaux standing among his murals
in the home of Mr. Gilbert Périer, in Brussels.

THE MYSTERY OF THINGS

"What first strikes one about your work are the objects—such as lamps and trains—that keep recurring."

"They are objects out of my childhood. The impressions recorded in childhood are the most lasting. These are the things I saw and marveled at. In trains and trolleys, there is very intense life, things which are part of the daily necessity, things that people use and never see. They had to be shown as never seen before. Actually, it's impossible to say why you like something..."

"What influence have Smet and Permeke had?"

"I had seen the Flemish painters. To copy a landscape from nature was all very well, but I felt it was necessary to go deeper. I went to shows, I felt Permeke's primitive strength. But I understood that it didn't go very far. Then I approached Ensor and I tried to find color ranges. Then, in about 1935-1936, Chirico: with him, I felt what was possible, what climate had to be developed, the climate of silent streets with the shadows of people you don't see. I never asked myself whether that was Surrealist or not. There was something to be derived from this void, this mystery. Then, I saw Magritte's work, which confirmed the direction my own painting was going in. But Magritte does painting and anti-painting at the same time. He didn't want to sacrifice to matter, to color. There aren't many colors in my work, but I place them carefully."

"How did your vocation become clear?"

"My parents pressured me into studying architecture for a year. In 1924 I began to work by myself, in an attic arranged as a studio. But before that, from 1921 to 1924, I had worked outdoors, on landscapes. I destroyed nearly everything. At the Academy, I learned to paint. I practiced my scales, so to speak."

"Why do you paint nudes?"

"A matter of taste. Why does an artist do a tree, or a flower? Because he is inspired."

"The women that you put in your paintings seem to be linked by silence."

"So I've always been told. I don't know. That's what makes my painting distinctive. Maybe it comes from observing Chirico, with his silent streets. It's my way of expressing the climate, the mystery of things. If I put in men, I do it for the contrast. The scholar you see in my paintings, always looking at something, is an exact replica of the illustration in Jules Verne's *Voyage to the Center of the Earth* in the Hetzel edition. I read Jules Verne at great length. I also made a point of reading the *Iliad* and the *Odyssey* several times, because you have to read them often in order to appreciate the savor of them. My studies of the classics, Greek and Latin, gave me a leaning for antiquity. That is why in some of my paintings I have included pediments and triumphal arches... not out of any desire to imitate antiquity but to surprise the viewer by mingling those elements with contemporary ones. I have been called the painter of 'gas meters and the Parthenon.'"

"What if you had to define yourself as a man and as a painter?"

"I've been told I'm a Surrealist. I don't say I'm not, but I'm not sure I really am one."

"And as a man?"

"I've never asked myself that question. I'm not interested in defining myself."

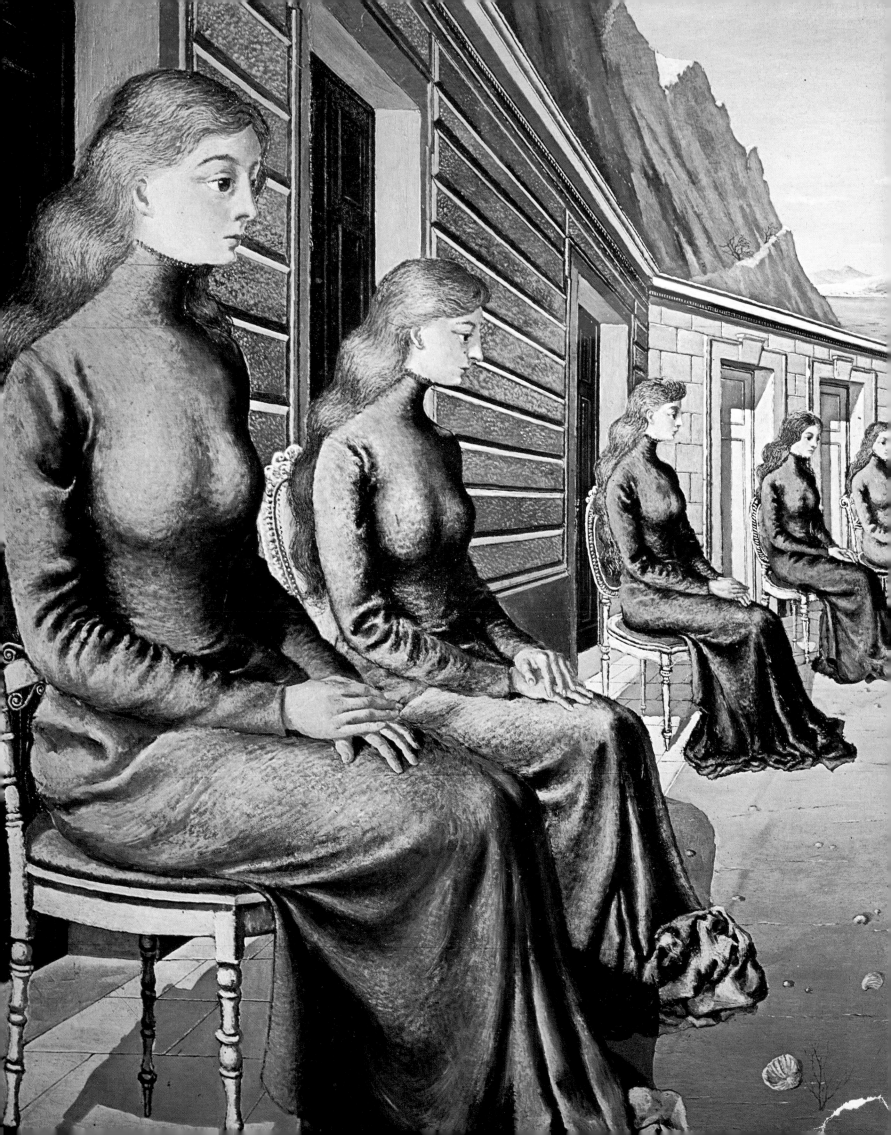

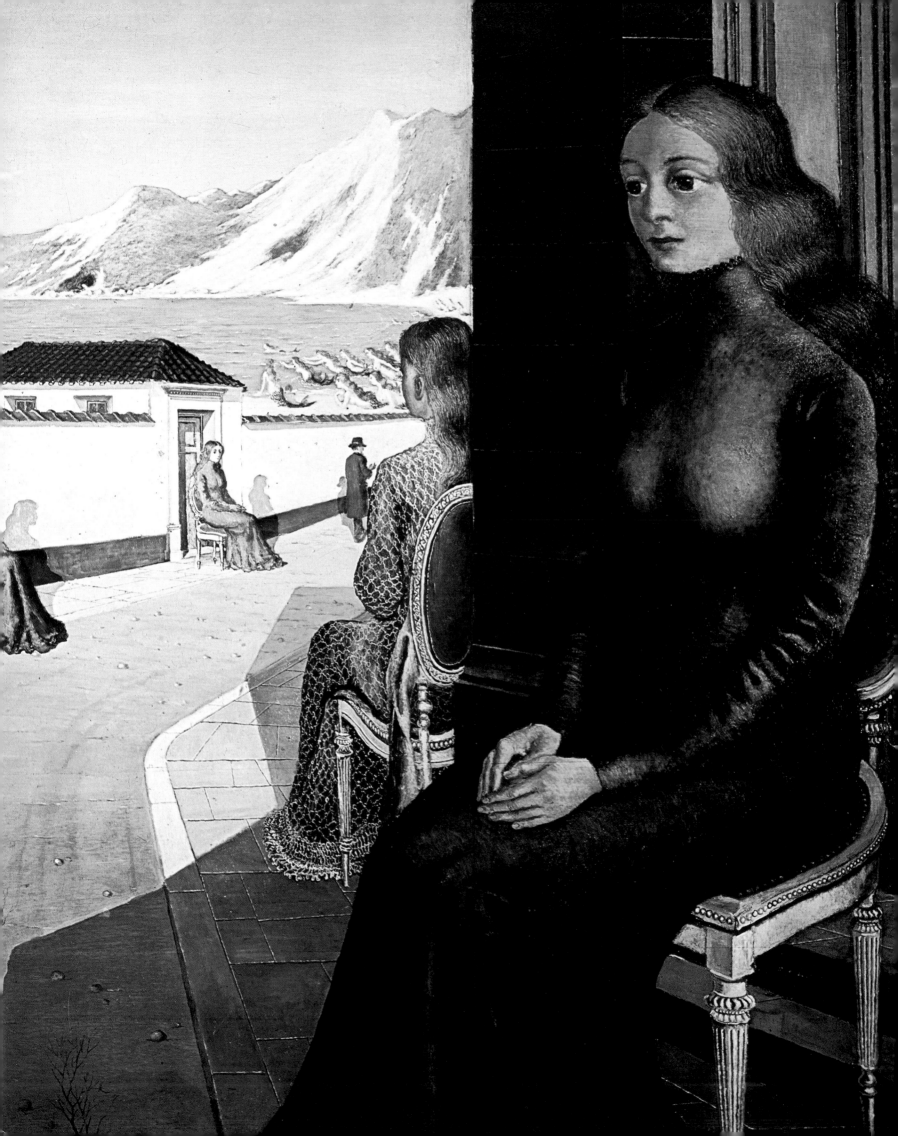

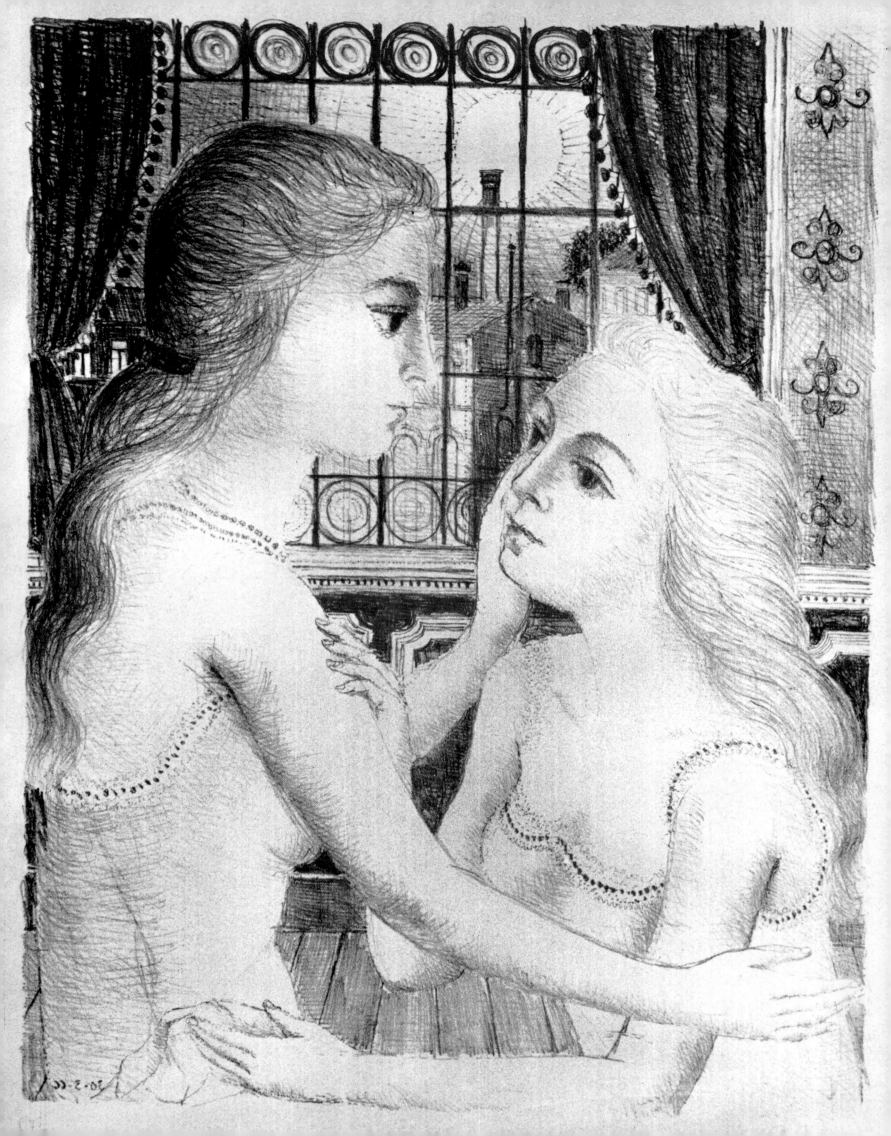

EXIL

à Paul Delvaux

Parmi les bijoux les palais des campagnes
Pour diminuer le ciel
De grandes femmes immobiles
Les jours résistants de l'été

Pleurer pour voir venir ces femmes
Régner sur la mort rêver sous la terre

Elles ni vides ni stériles
Mais sans hardiesse
Et leurs seins baignant leur miroir
Œil nu dans la clairière de l'attente

Elles tranquilles et plus belles d'être semblables

Loin de l'odeur destructrice des fleurs
Loin de la forme explosive des fruits
Loin des gestes utiles les timides

Livrées à leur destin ne rien connaître qu'elles-mêmes.

Paul Eluard

EXILE

for Paul Delvaux

Amid the jewels the country palaces
Diminishing the sky
Tall women motionless
On resisting summer days

Crying to see these women come
Reign over death dream below the ground

Neither empty they are nor sterile
But lacking boldness
And their breasts bathing their mirror
Naked eye in the glade of expectation

Tranquil they are and more beautiful for being like

Far from the destructive odor of flowers
Far from the explosive shape of fruit
Far from the useful gestures the timid

Consigned to their fate knowing nothing but themselves.

Paul Eluard

Preceding double page:
Mermaids' village . 1942 .
42 x 50.8 (detail)

Left: The secret . 1966 .
Original lithograph.
26 x 20

IN THE GLADE OF EXPECTATION

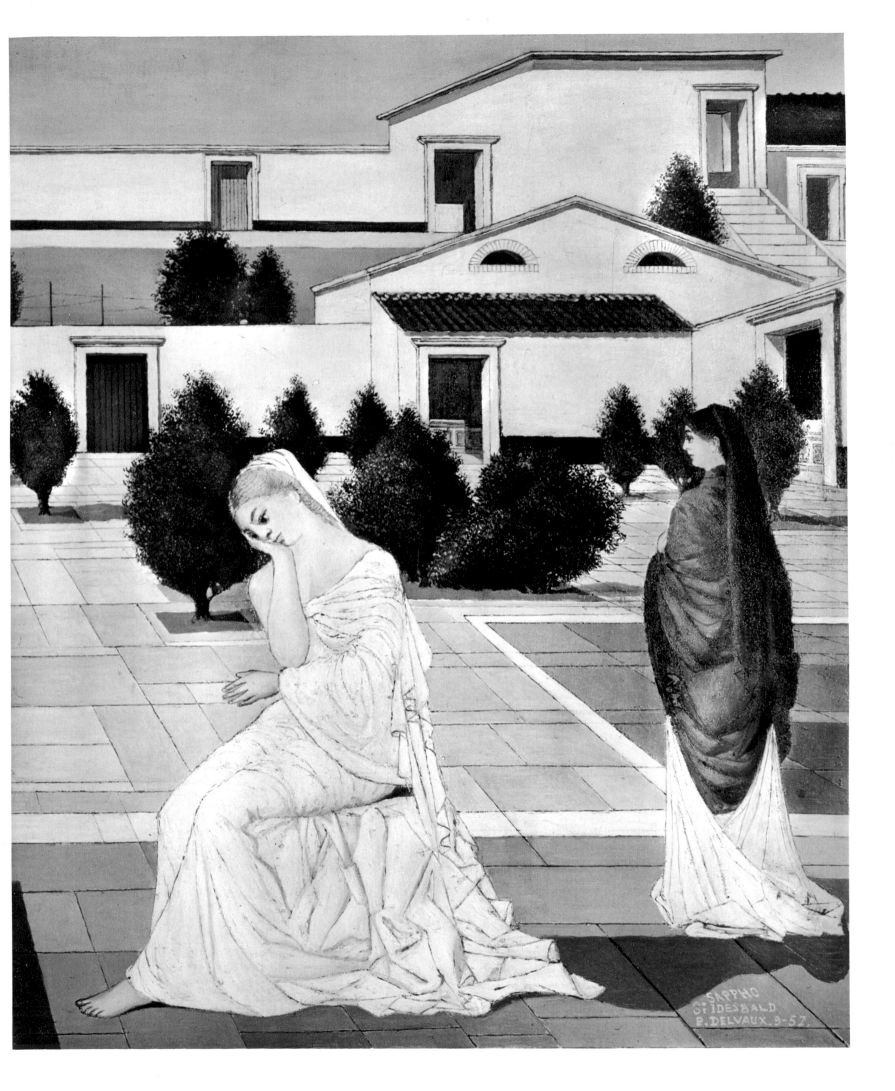

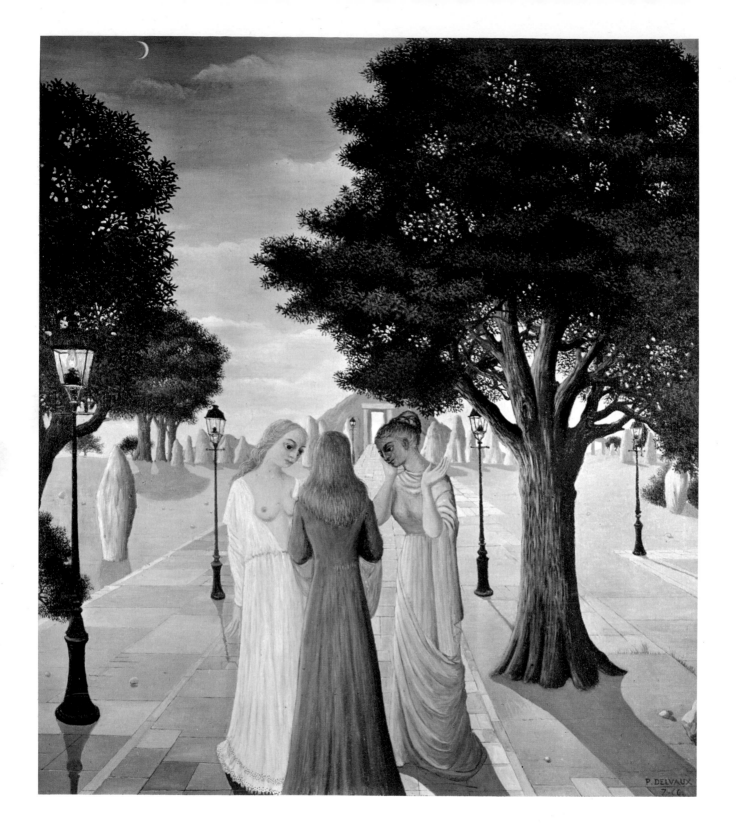

Preceding page:
Sappho . 1957 .
36 × 56 (detail)

Above: Evening prayer . 1966 .
60 × 52

Right: All the lights . 1962 .
60 × 52

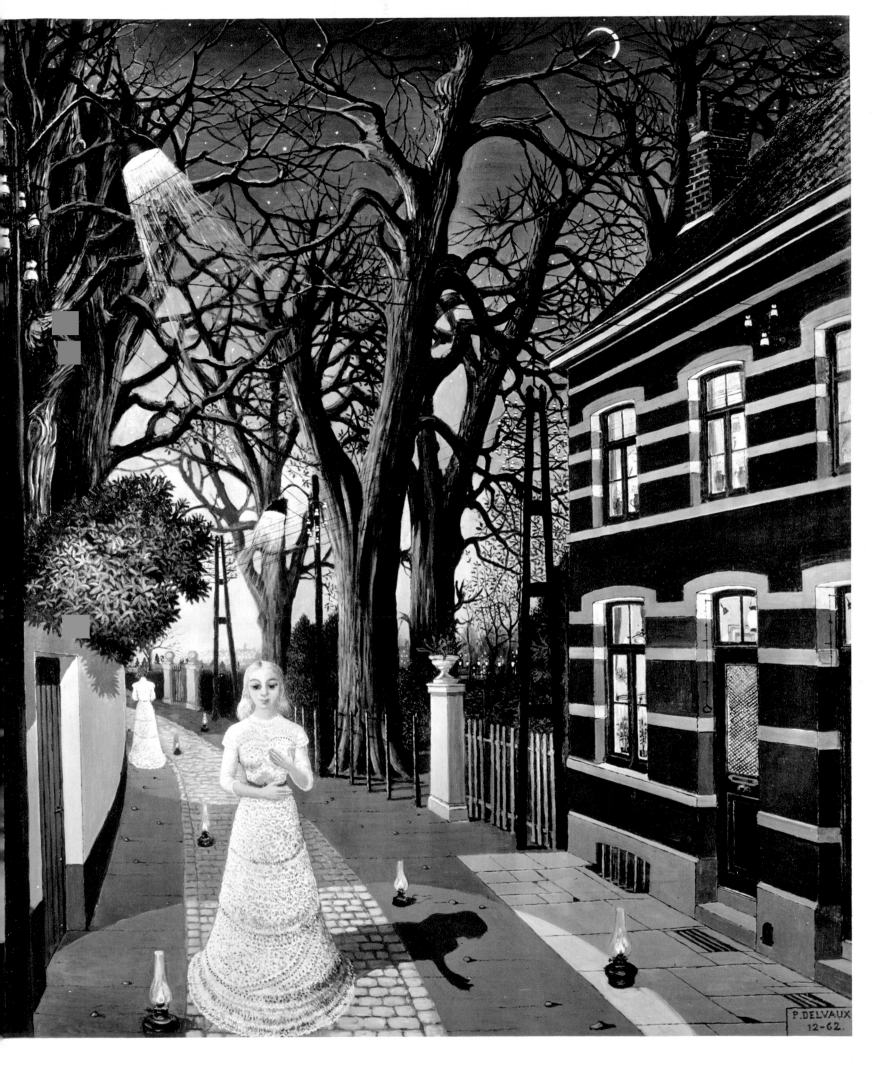

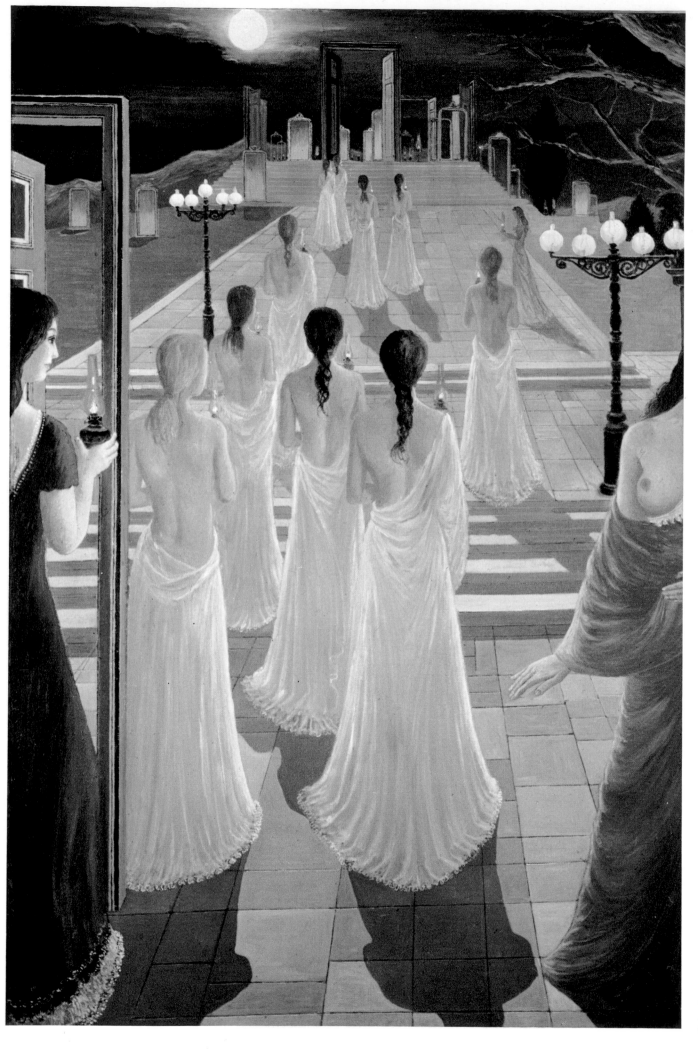

The Acropolis . 1966 .
60 × 92 (detail)
Right : The cortege 、 1963 .
44.8 × 56

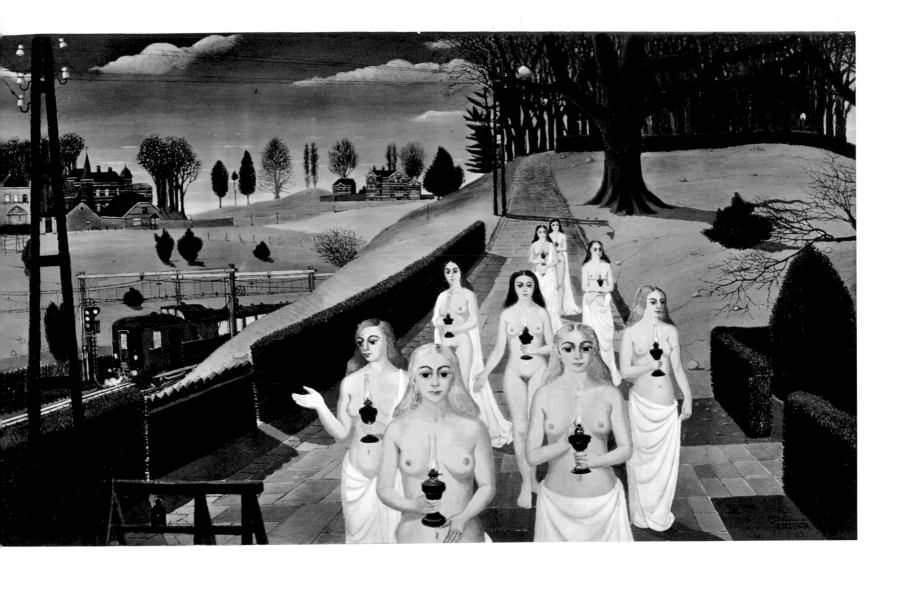

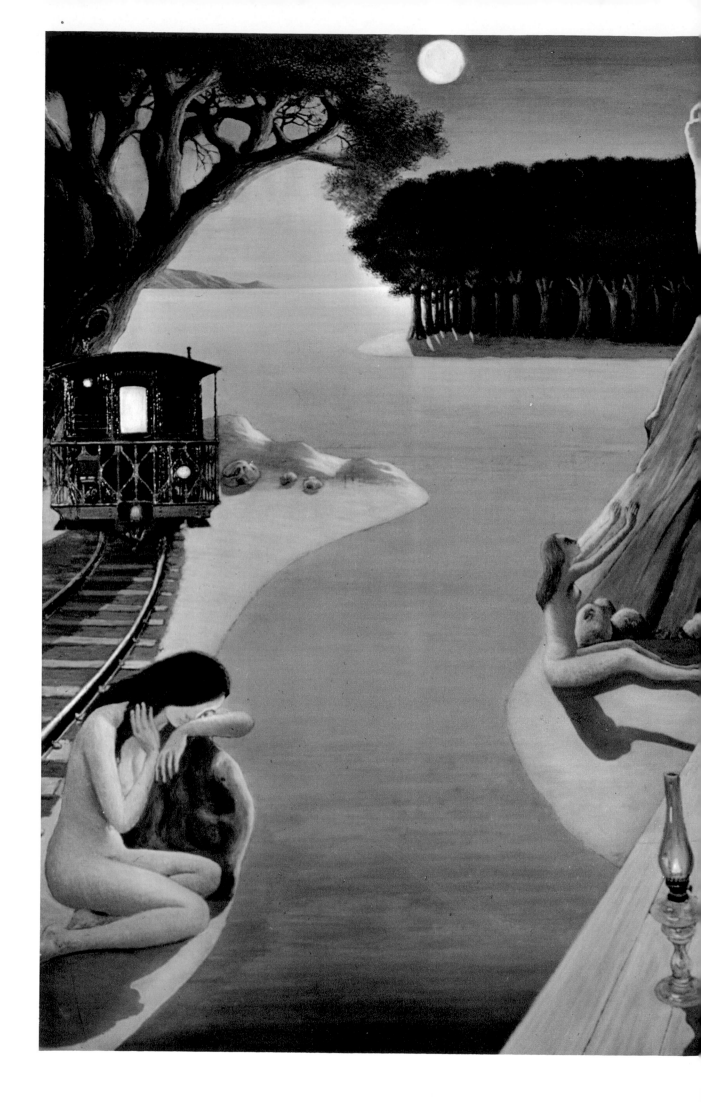

The end of the world . 1968 .
64 x 96

24

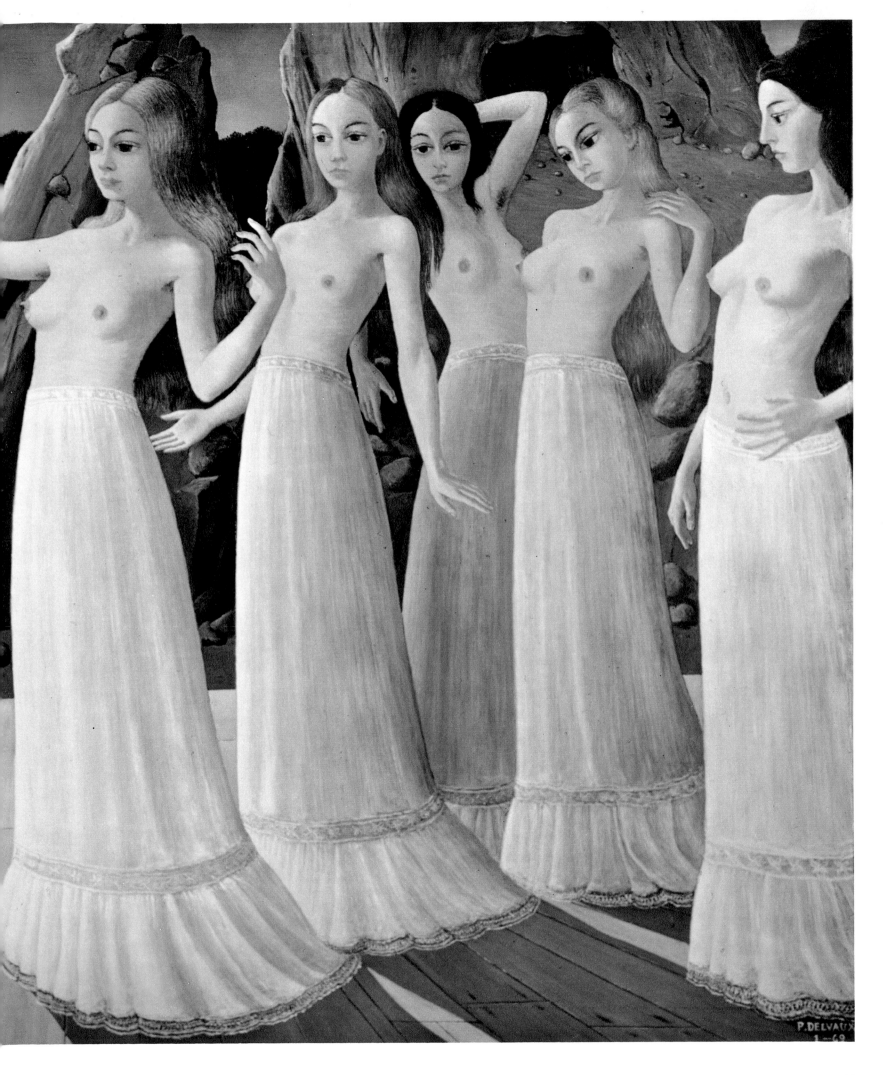

The strange power of this painting. On the one hand, what belongs to all eternity: the dramatic landscape of destiny and fate; on the other, the reality of day-to-day, in minute detail. In an architectural setting straight out of classical antiquity, or among spruce and sober suburban houses, the very certain presence of uncertain women. And soon the spectator doesn't know himself whether he is dreaming or awake. The garden gate of one house jostles the pediment of a temple; the columns of a palace are lighted by Chinese lanterns; and what is that small round table doing in the stone-paved street leading out of sight?...

Astounding contrasts, revealing the importance of memory and imagination in this very orderly vision. The instant we see is like the photograph of a dream. Or is it a film? The woman over there seems to be multiple, like the successive images of a cartoon strip, with movement implied from each one to the next. Or is it an effect produced by many mirrors? No, it is the painter who has organized his memories and given shapes to the things that haunt him. From his studies of the Greek and Latin come these fresco-like backgrounds and the figures that stand out before them, in the drapery of tragic actors. The streets, the placid houses, the little railway stations are those of the suburbs and the villages where he spent his childhood and adolescence. And if these nude women convey uneasy expectation so well, perhaps it is because they are born of his own confused desire, his own solitude. The daring and sometimes almost provocative nudity of the pubes, combined with the serenity of each face, creates a curious impression of panic having been reined in, overcome — mastered. After the initial seconds, we know that nothing is about to happen. Here is where we encounter a feeling of fatality, the solitude of human beings, incomprehension between them, the distance which separates them.

Even in the corteges and processions, where these demure and foolish virgins come together, they are isolated from one another. Each one regards the landscape in her own way. The geometrical regularity

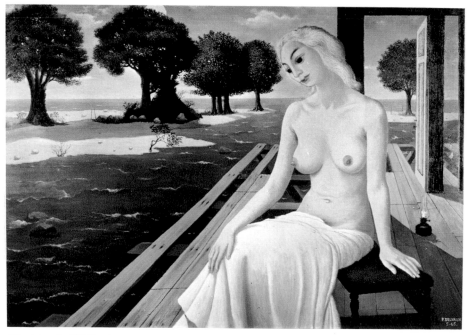

The island . 1965 . 48.8 × 70.8

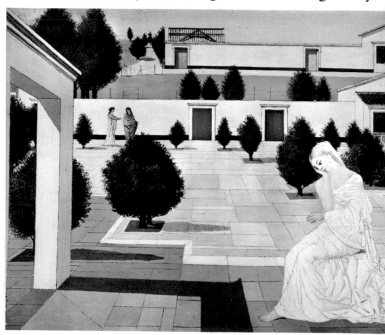

Sappho . 1957 . 36 × 56 (detail)

of the distant background and even of certain pavements exudes an indifference that heightens the drama going on inside these women. These strange confrontations—do they derive from Magritte? And these virtually deserted streets and forums—from Chirico? Paul Delvaux has acknowledged his debts to each of those painters. "With Chirico, I felt what was possible, I felt the climate that had to be developed, a climate of silent streets with the shadows of people you do not see. Then, I saw Magritte's work, and it confirmed me in the direction I was moving in." Leaving behind neo-impressionism and expressionism, he headed for this transcription of all the stages of anxious and apprehensive thought. But here the poet stepped in. The details from childhood that suddenly come back to mind, taking on an unforeseen importance, the adolescent torments that cling to the grown man and add to his anguish in the face of destiny—these things Delvaux sublimated, made into the elements of a privileged world where the imaginary comes true. The relays that memory travels over are suddenly developed and brought to light, associated with all the phantasms of the imagination. These canvases convey an insinuating poetry. No sudden shock, none of the provocation of opposites intermingled, as in Magritte or Max Ernst. Nothing of Lautréamont's "chance encounter of a sewing machine and an umbrella on a dissecting table." Delvaux is not really a Surrealist. No longer are these objects altogether unexpected, these lamps, mannequins, small tables, beds which appear and reappear in his work until they become indispensable accessories; but their presence close by the arcades or the great metallic structures, or in the street, on the sidewalk or opposite a railway station continues to haunt and intrigue whoever has seen them. The viewer is subject to the interpretation of a symbol or a blurred dream within the rigorous arrangement of the composition. And those impassive women, so near and yet so far, dwell in his memory—perfectly white, perfectly elusive shadows.

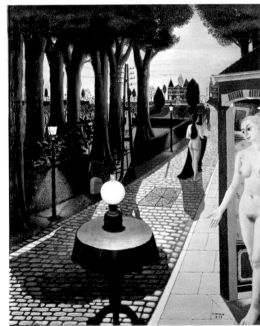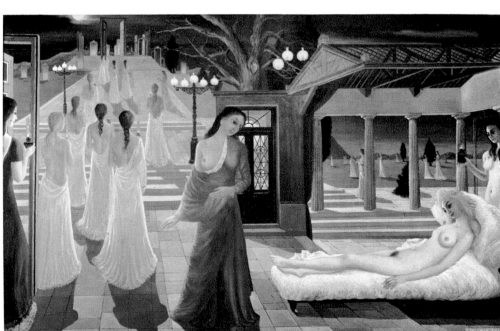

The offering . 1963 . 56 × 44.8

The Acropolis . 1966 . 60 × 92

NEITHER EMPTY THEY ARE NOR STERILE

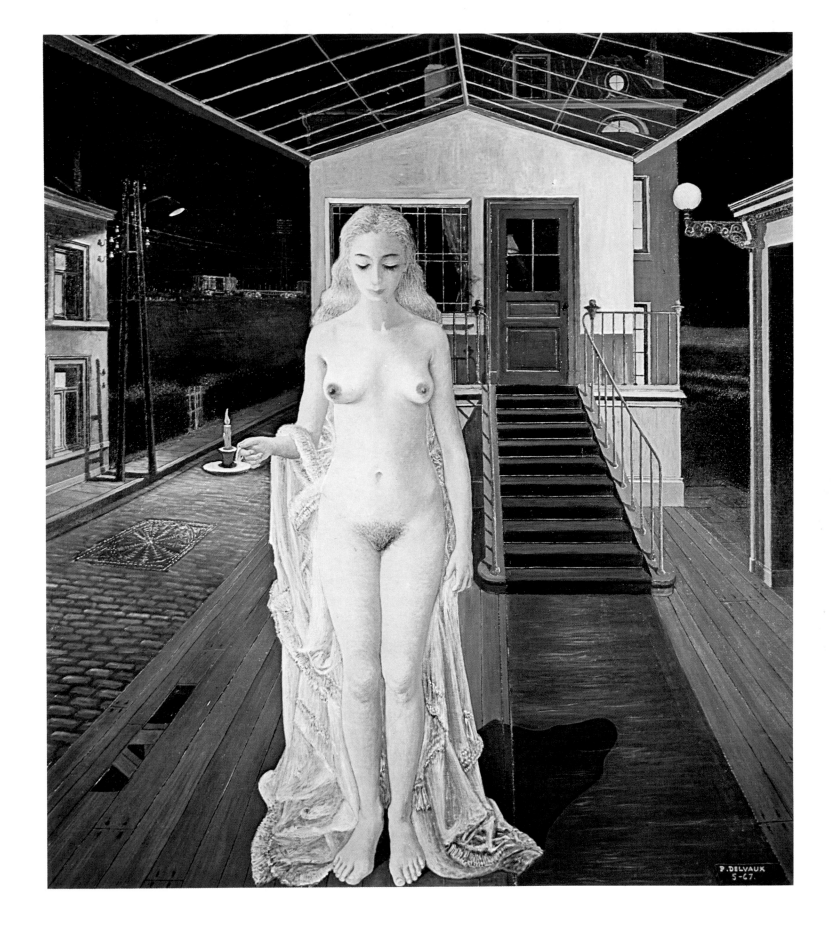

TALL WOMEN
MOTIONLESS

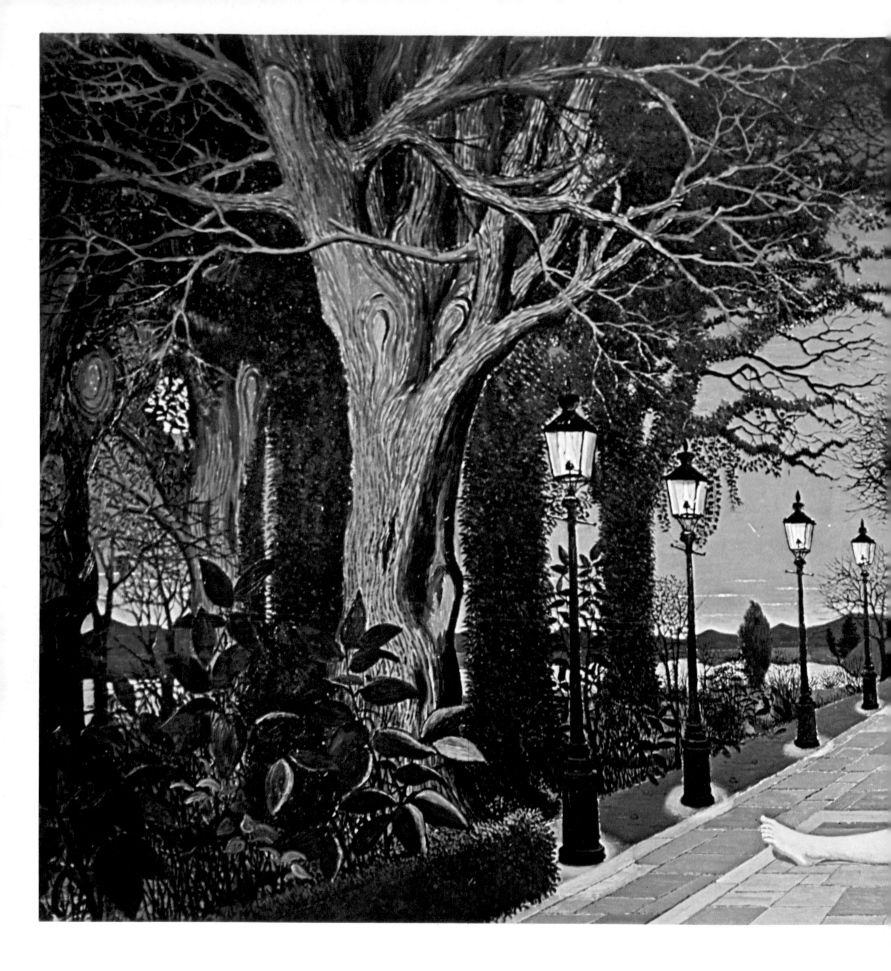

Previous page:
Chrysis . 1967 .
64 × 56

Above: Aurora . 1964 .
48.8 × 97.6

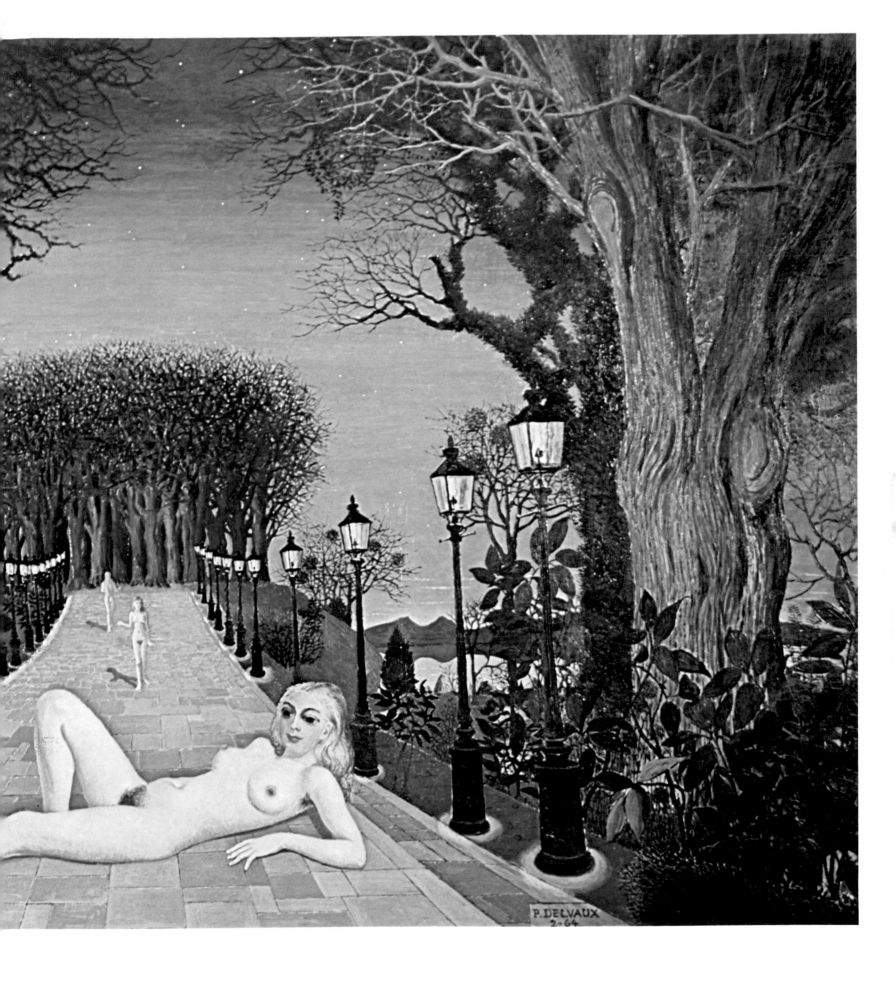

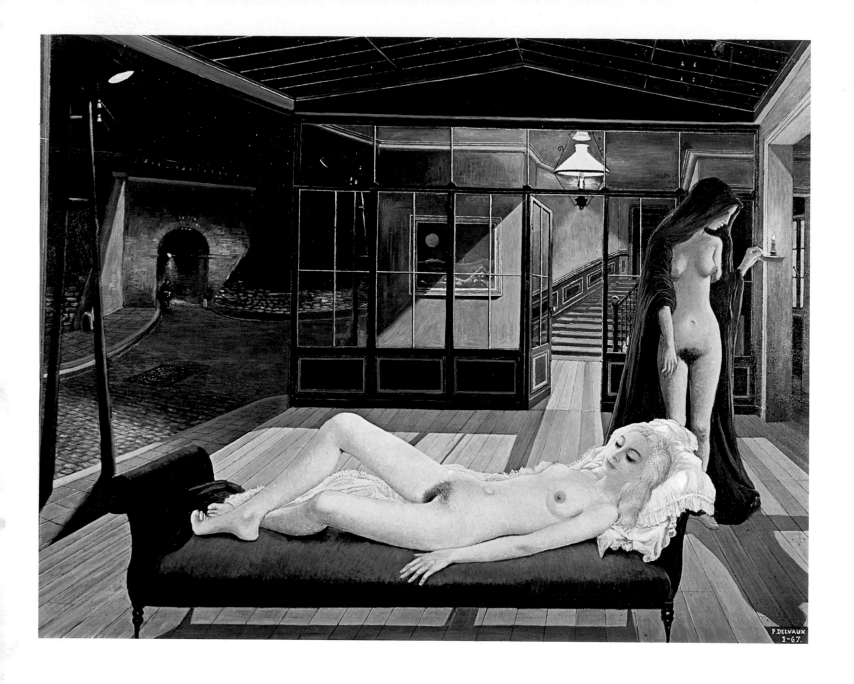

Above: The blue sofa . 1967 .
56 × 72
Right: Women walking . 1947 .
52 × 72

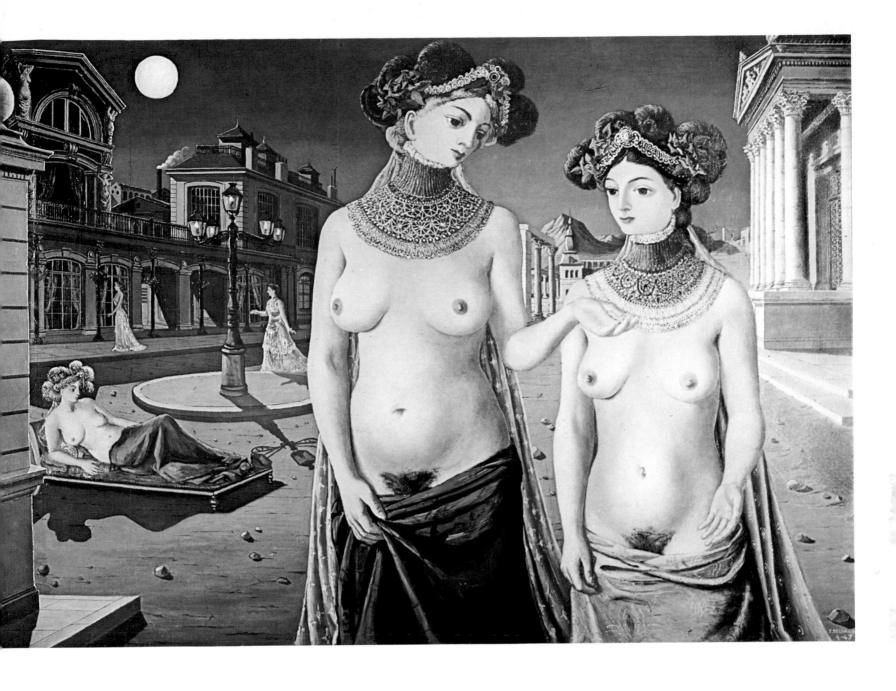

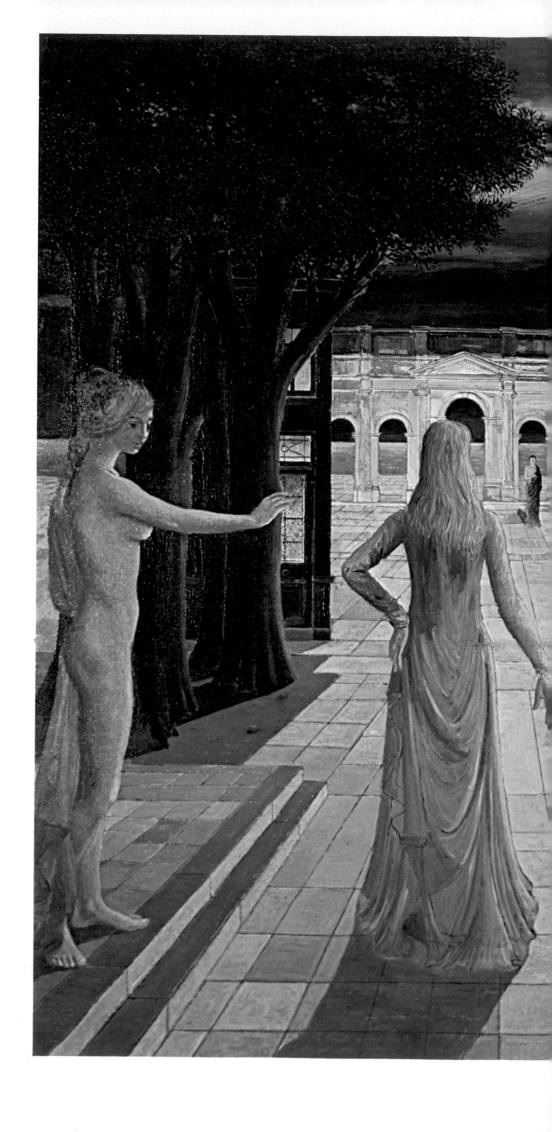

The sea is near . 1965 .
56 × 76

34

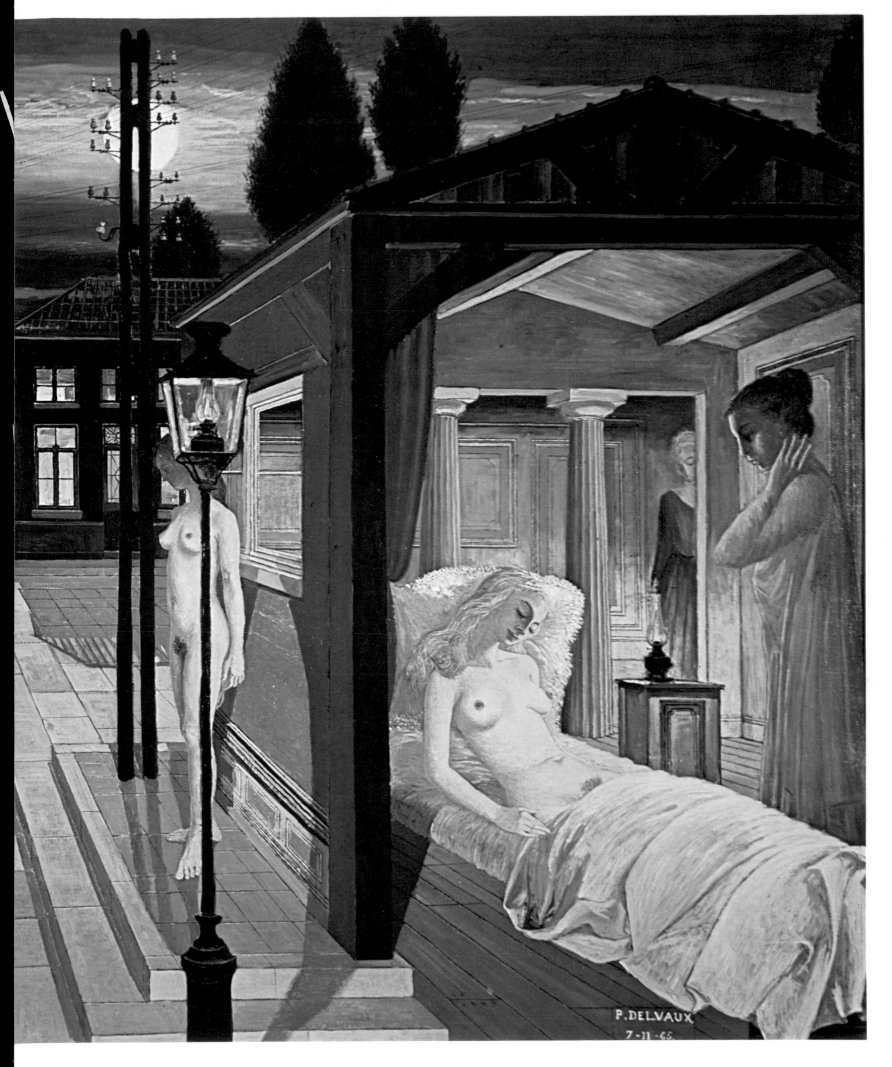

35

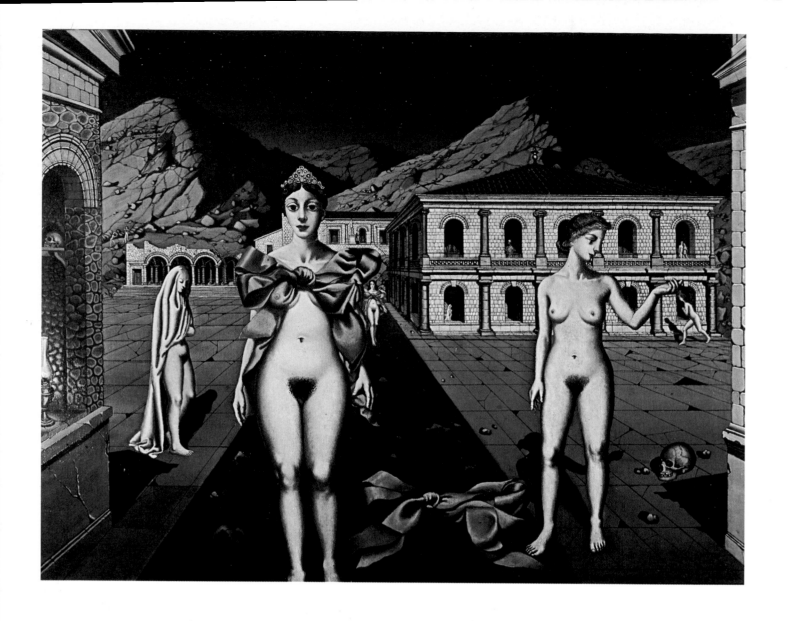

Above: The pink bows . 1937 .
48.6 × 64

Right: The phases of the moon I . 1939 .
54 × 64

Following double page:
The sabbath . 1962 .
64 × 104

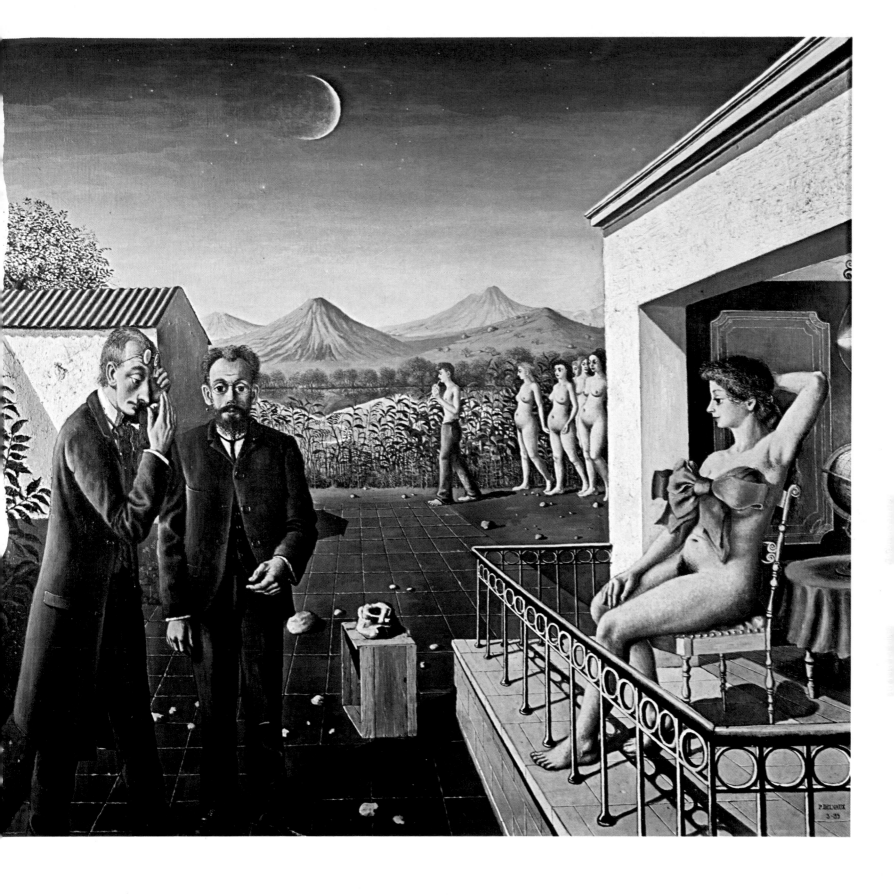

FAR FROM THE USEFUL
GESTURES THE TIMID

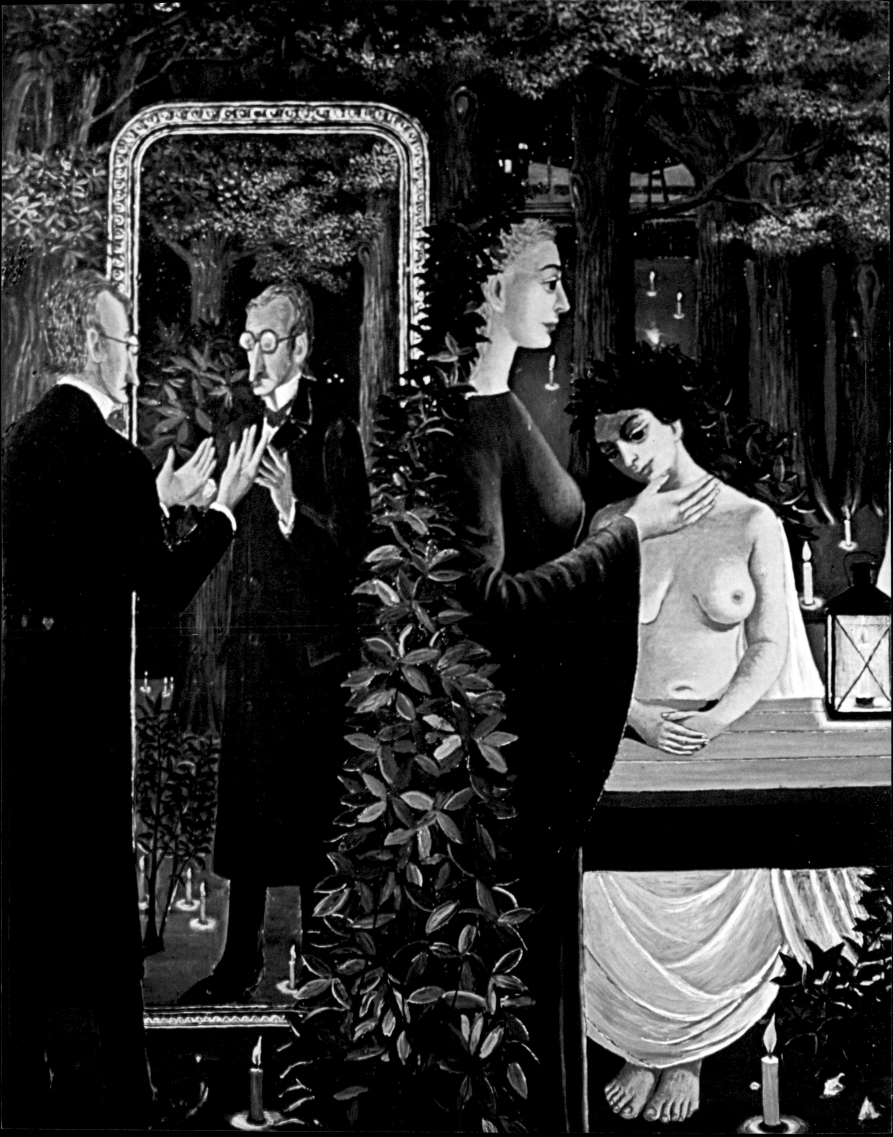

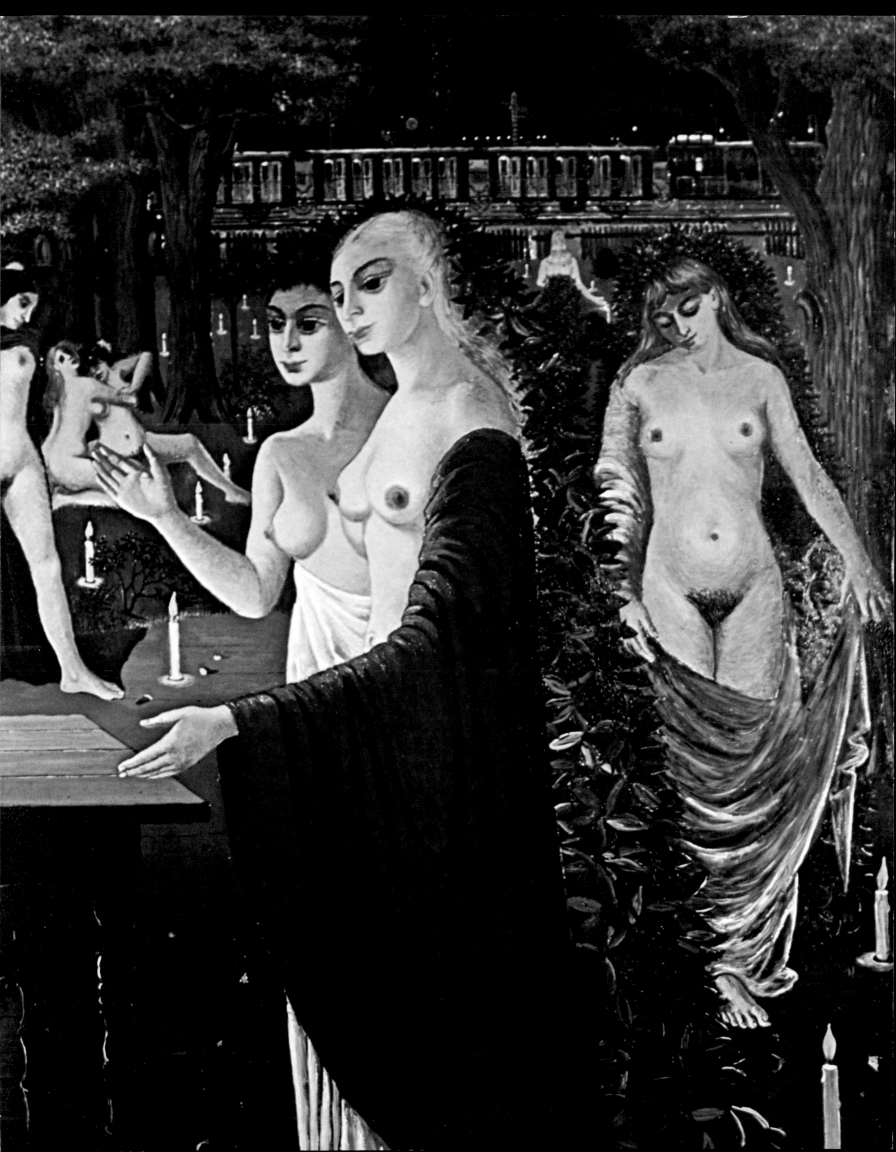

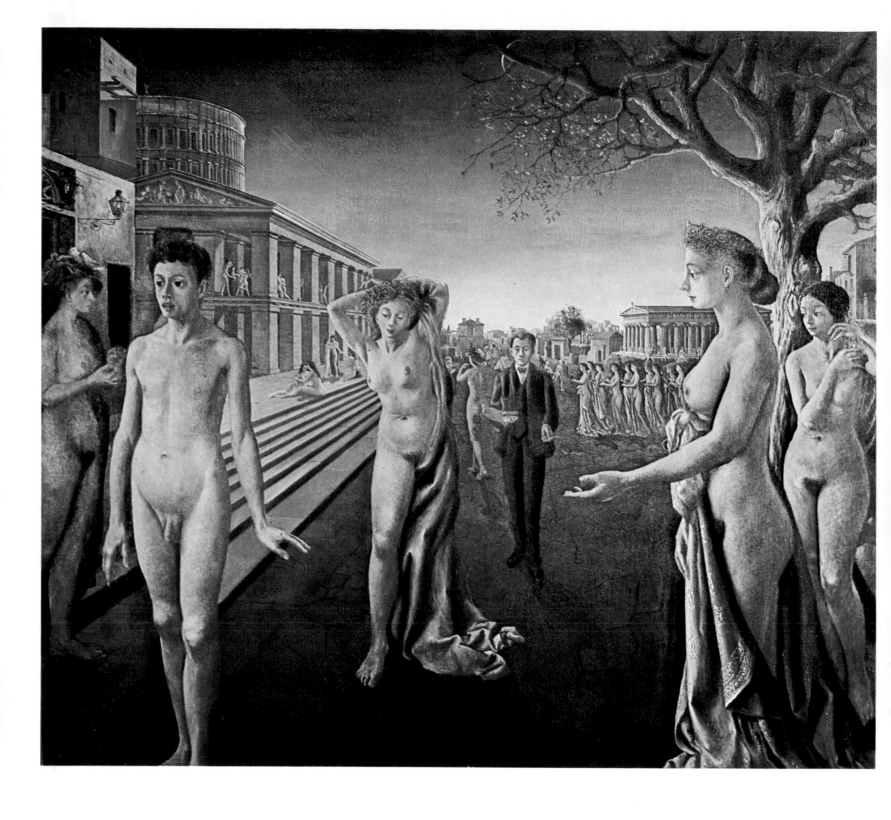

Dawn over the city . 1940 .
70 × 86
Right: The man in the street . 1940 .
52 × 60

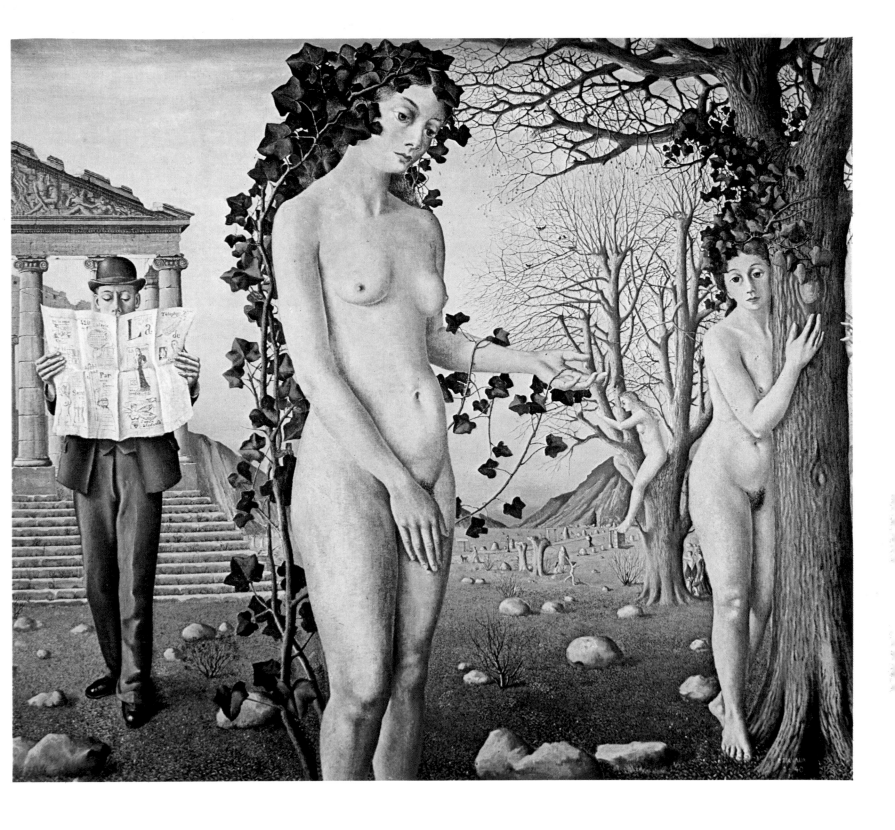

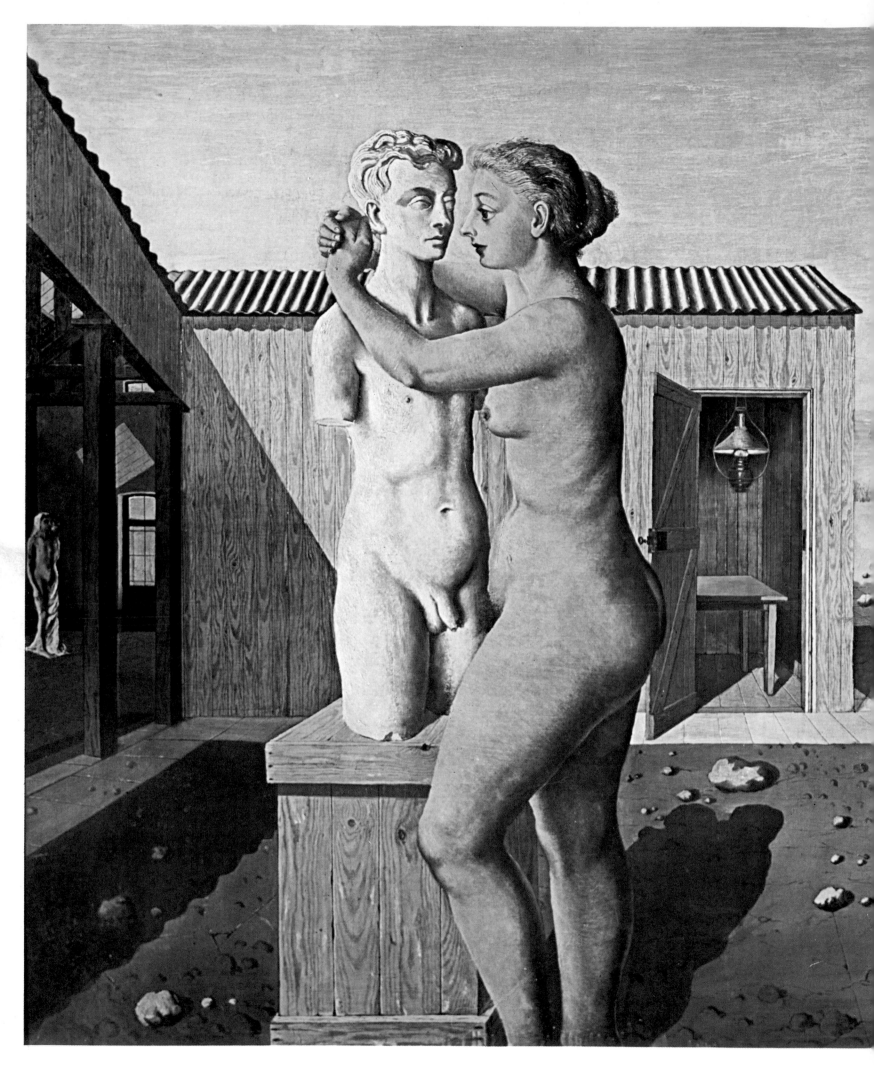

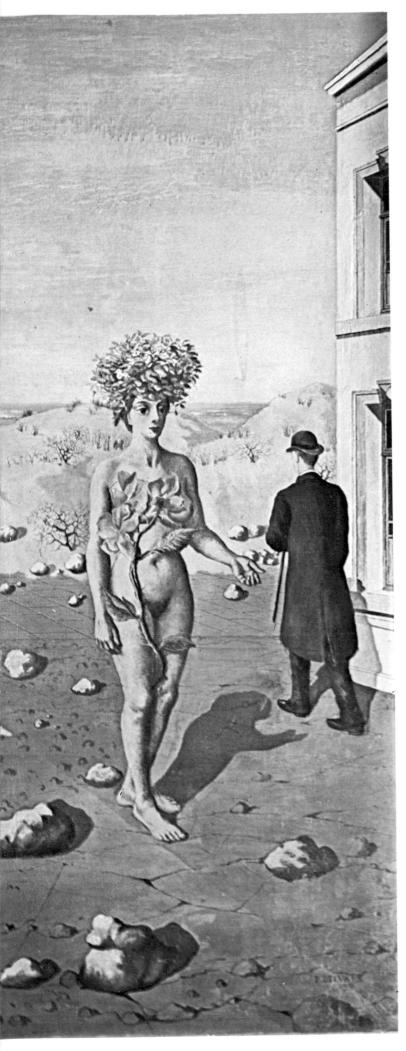

Pygmalion . 1939 .
46.8 × 58.8

It is the end of the night. A long avenue rises gradually to the distant forest. Suddenly a woman lies invitingly across the stone-paved roadway. Is this white apparition lighted by the street lamps? Or is it they which receive their lantern light from her? At the same time it is night, an evening atmosphere in the city. Again the dream architecture, temples and columns amidst successive glimpses of railway stations and illumined palaces. The moon is very round in the sky or concealed by clouds made iridescent by its rays; film visions, their intermeshed details taken l ne by one from the depths of memory and opening all the doors of dreams. Here are the corridors and passageways between shadow and light, peopled by all the creature of desire, precise, inaccessible marvels: "*Les voûtes de la nuit, caresses idéales,*" 'The vaults of the night ideal caresses.' Many resemblances between these women: all make the same slow gestures. One comes forward, another moves away, and the step is the same: a majestic Renaissance gait, emphasized by drapery. These are the gestures which accompany offerings and extend the offer of the body, un veiled, revealed. They would be as splendid as statues were it not for the languishing poses in which they lie on the ground, the slightly parted legs, the way the painter insists on the roundness of the breasts and the fleece of pubic hair, triangles of black or blond sometimes in the very center of the painting. The interplay of contrasts gives these paintings a sort of uncertain temperature; even the colors are somewhere between freezing and burning. Where you would expect warm, bright tones, you find light, almost cold tints: the time-softened colors of frescoes. The lines and strokes used, on the other hand, are infinitely more sensual. They hug and caress the forms we see, making for firm contours signifying desire and the instinct of possession. Having left the temple steps behind, a man wearing a hat reads his newspaper. Elsewhere, a botanist is absorbed in the study of a plant. Over there, a young man goes by without a glance. Are these men indifferent to the beauty that surrounds them? Then these women's gestures take on overtones of despair. Ridiculous their jewels seem, their necklaces like high

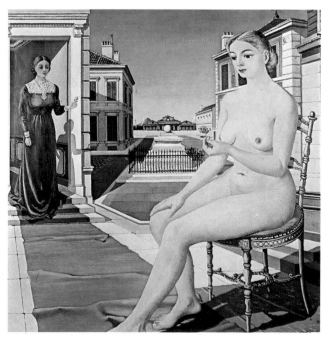

The first rose . 1947 . 50 × 50

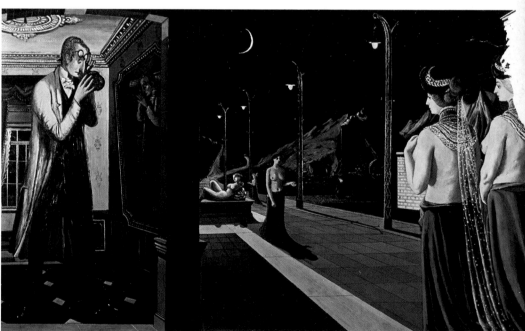

Women walking and scholar . 1947 . 48.8 × 97.6

dog collars, their diadems, their large flowered hats, those gigantic bows around their breasts. *"Elles ni vides ni stériles. Mais sans hardiesse..."* are that much more alone, misunderstood, overlooked. Each of these women brings to mind the end of Marie Laurencin's poem: *"Plus que morte, oubliée"* (More than dead, forgotten). But what about Delvaux himself? What about that man who turns his back? and the painter who holds a palette in his hand but has no canvas, no easel, who is thinking only of his own colors? Through a reversal of the situation, don't they express his own timidity of fear? Obsessive desire, yet fear in the presence of a woman. Regret, possibly remorse at not knowing how to take advantage of what is so alive all around him, and a conviction, at the same time, that these marvelous creatures are out of reach. Or again, it might be a very twentieth-century obsession that is expressed through these irreconcilable situations, from which there is no way out: in an unstable world subject to upheavals, how could sentiment itself emerge unscathed? These arcades and pediments, these metal-frame structures appear to be time-proof, wear-and-tear proof; they represent what is eternal amid the fleeting days, they offer orderliness, a refuge, a reassuring element, like those checkerboard tiles—their geometrical regularity reminds us of Vermeer's interiors or Mondrian's constructions.

Yet Delvaux's women remain young. No ageing, here. It would be a pity, really, if they were to pine after these scholars with their nightmare faces, these still gentlemen who overlook them—and who, as the painter explains, are there "to set off the mystery, to add a note of contrast." Yet amid such indifference, how are these women to know that they are beautiful? Even that statue of Pygmalion, that tree to be leaned against are more receptive than these cold men who turn their backs. Who turn their backs... So, the women fall back on themselves:

Pour connaître la forme et le poids de ses seins, "To know the shape and the weight of her breasts,
La plus belle au matin s'enferme dans ses bras." "The loveliest one in the morning enwraps herself in her arms."

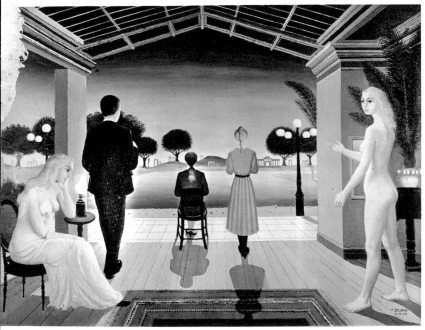

The forgotten city . 1964 . 56 × 72

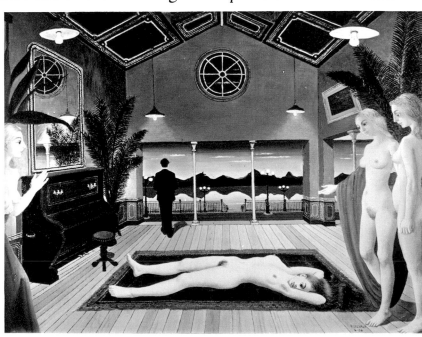

Abandon . 1964 . 56 × 64

MORE
BEAUTIFUL
FOR BEING
LIKE

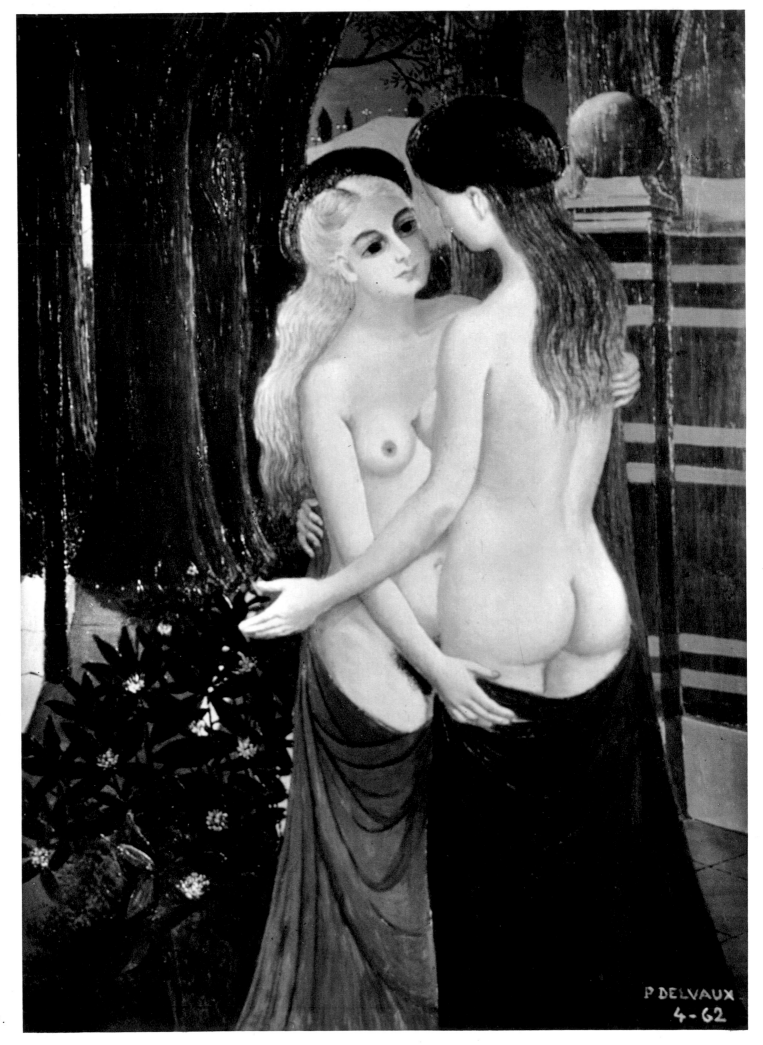

Sweet night . 1962 .
54.8 × 76.8 (detail)

47

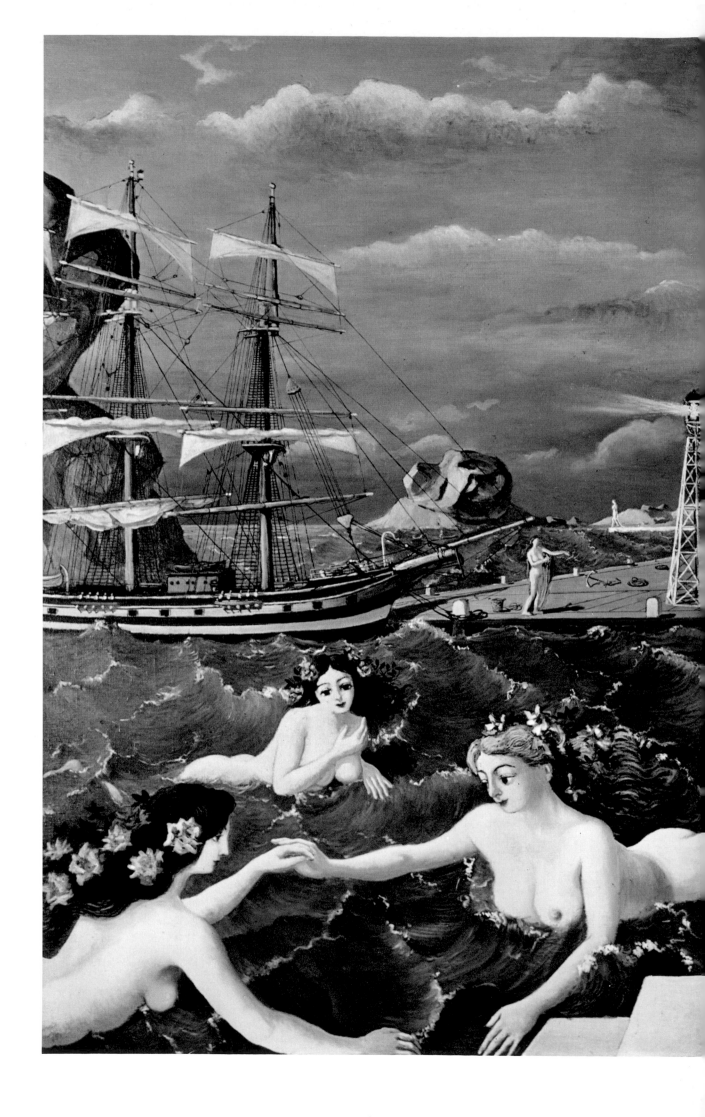

The birth of Venus . 1947 .
48 × 56

Following double pages:
Water nymphs . 1938 .
52 × 60 (detail)
La voix publique. 1948 .
60.8 × 61.1

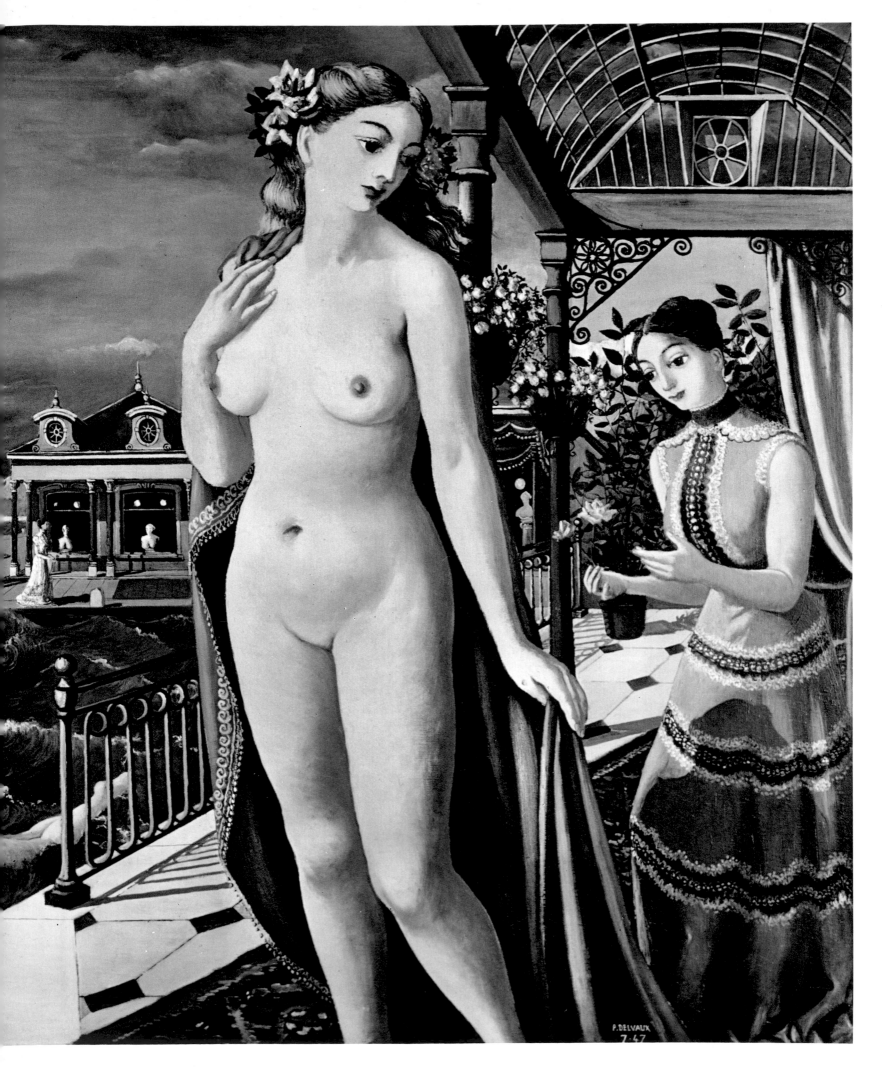

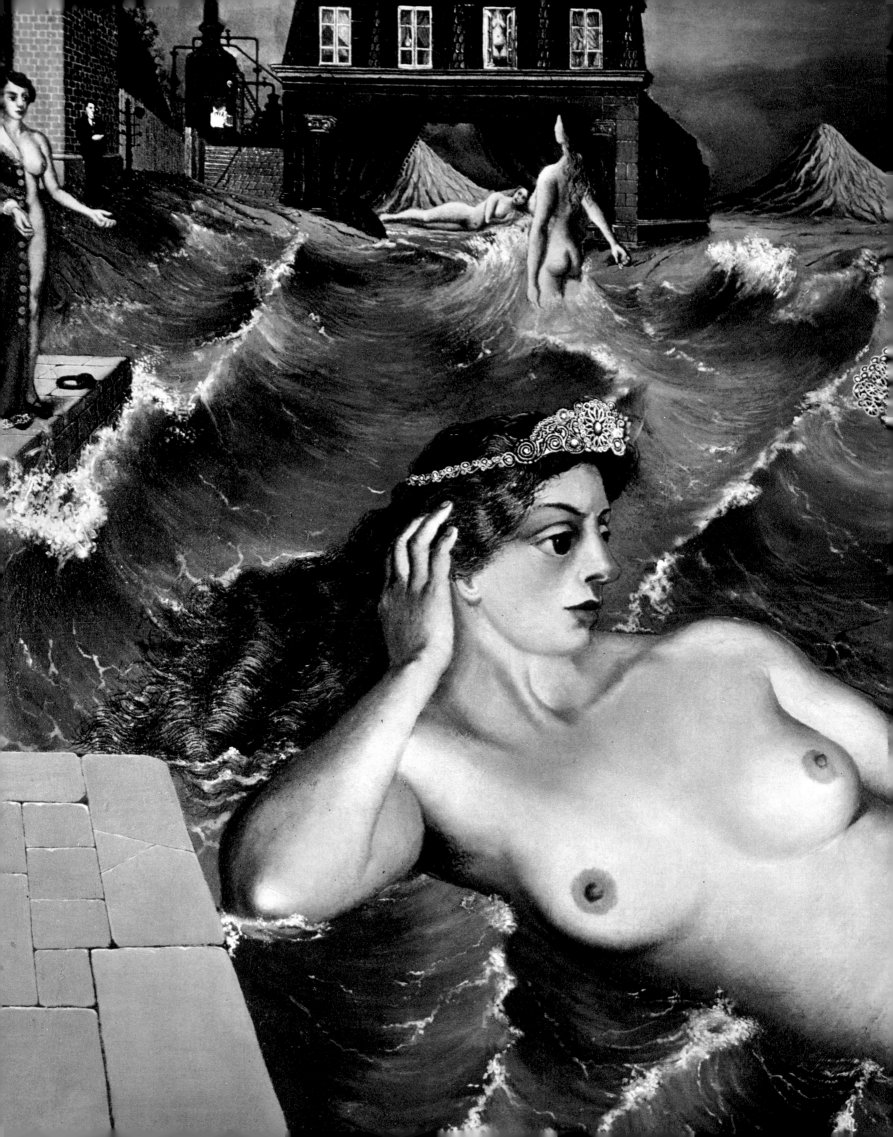

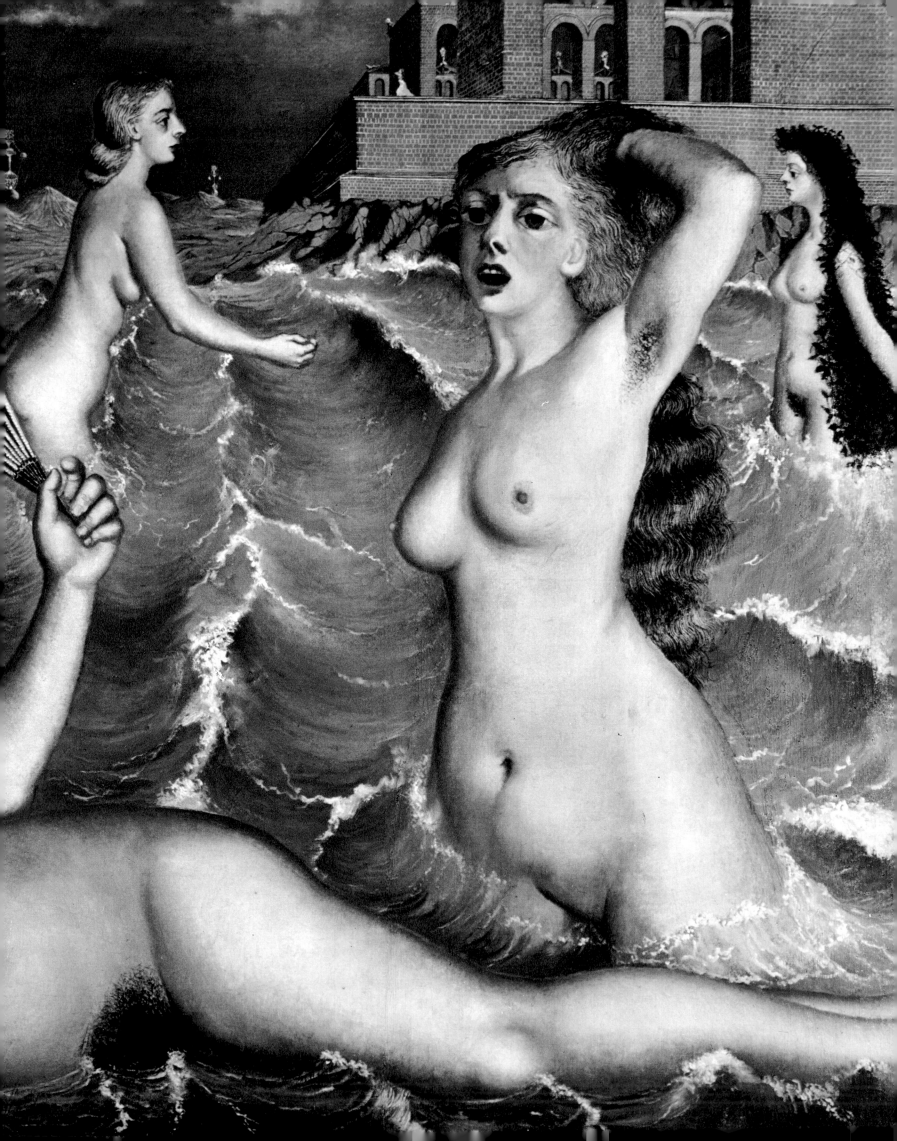

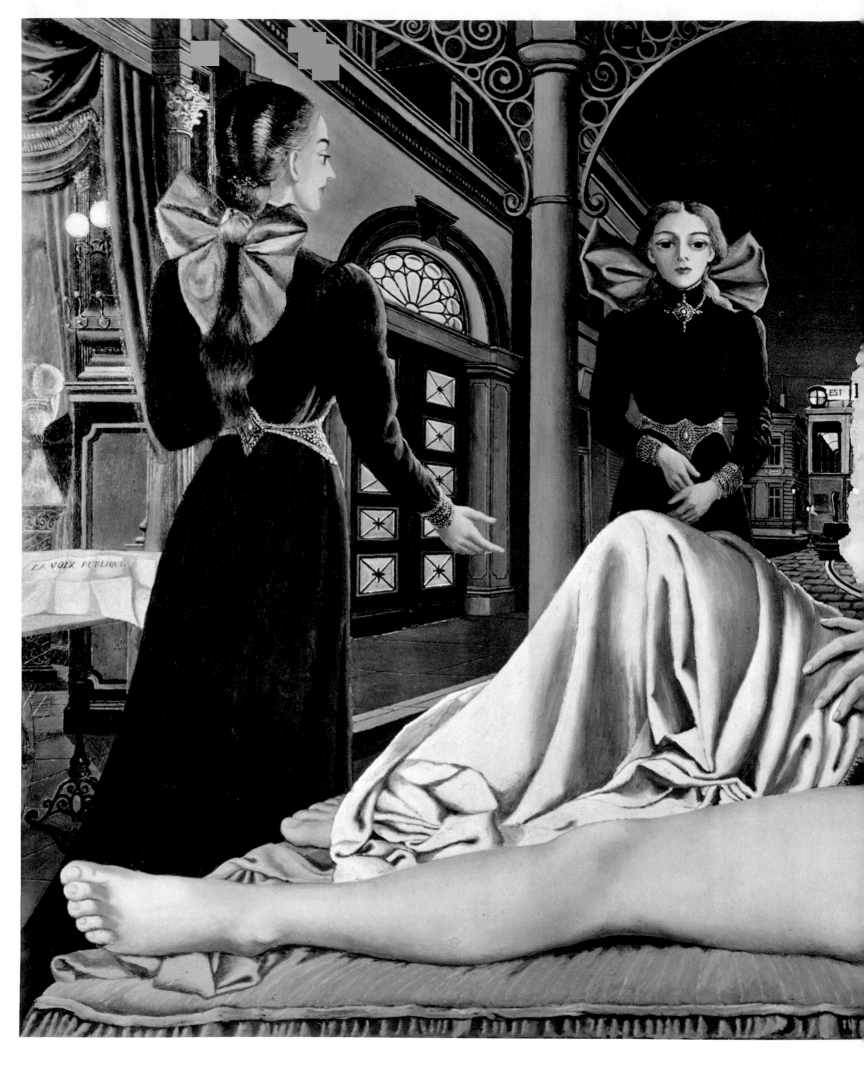

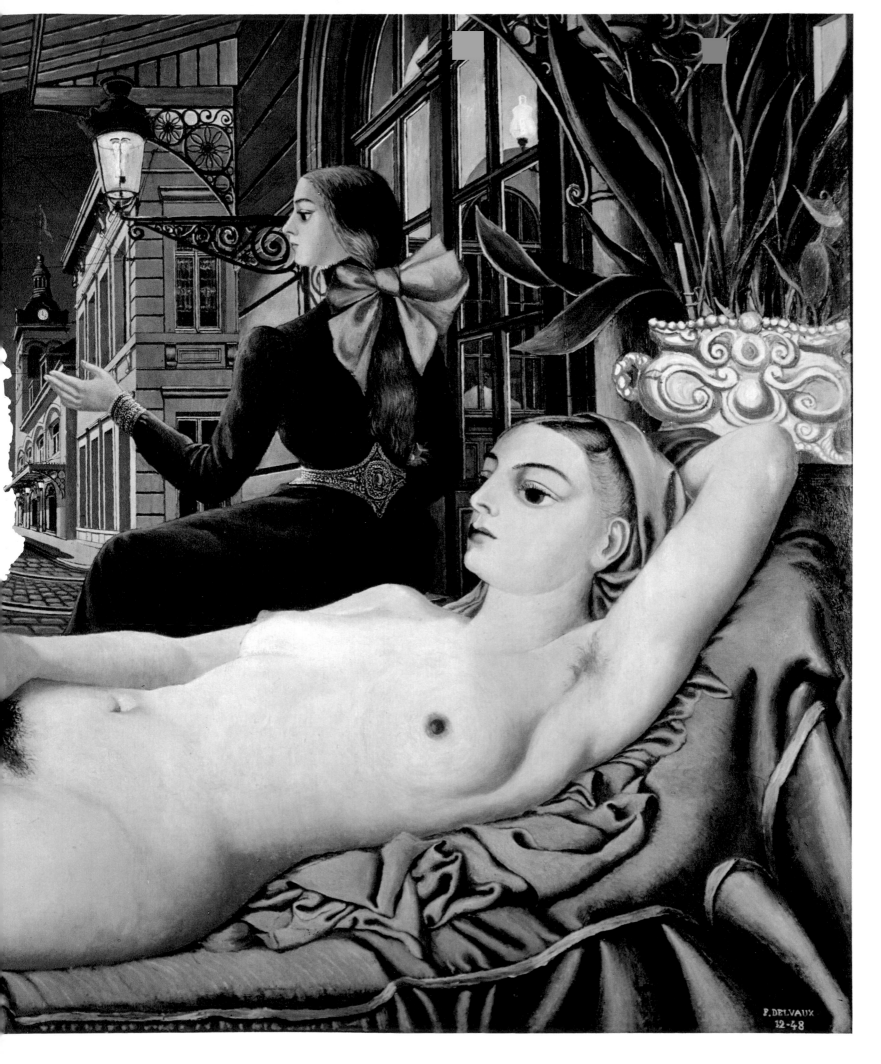

Is this day or night? The lanterns outside and the lamps inside the houses are lighted, but everywhere there is a dawn— or dusk—like light. "A mineral radiance," wrote André Breton. It is not dazzling; its even glow unveils the world and plays with the shadows more gently than the rays of the full moon; the interlacing of the trees' rounded branches is multiplied on the ground; the human figures are duplicated. Shadow is the echo of light, a silent echo which disturbs and sharpens our gaze; never are our eyes so wide open as in these indistinct regions where fear may leap out of hiding.

Once again here is the cleanshaven scholar, wearing a redingote, standing in the little forest that borders the railway station and the town's outlying houses. As if Delvaux wanted to turn the man's fear in the presence of woman into the woman's fear in the presence of man, and even justify it. But where is there any way out of this solitude? Already, wearing schoolgirl berets on their long hair, the maidens are standing together. Their bare breasts almost brush against each other. In a gesture of invitation and also of waiting, their arms open—and do not close. They do not really clasp one another, their bodies do not touch. There is never any embracing in these scenes which always verge on embracing. As the gesture is about to culminate, it is halted, arrested or sidetracked. Eroticism unsated, out of fear, fear of failure. The drama continues within... The open hands, ready for abandon and caresses, are warmed at an invisible flame. Rarely do they reach all the way to the flower they wish to pick. These women among women are beautiful only for themselves. Their studied poses, sometimes reminiscent of the Italian mannerists or the painters of the Ecole de Fontainebleau, seem no longer destined for any beholder but their mirrors. Their gaze is absent, "bewildered," says Maurice Nadeau, the gaze of someone observing and discovering himself, a stranger, in the glass.

This gold, these pearls, these bouquets woven into their tresses—like Botticelli's details, they are no longer

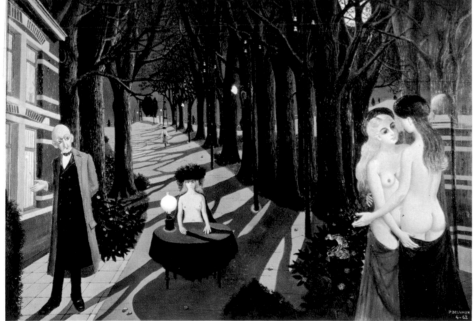

Sweet night . 1962 . 54.8 × 76.8

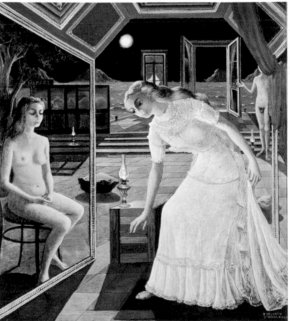

The mirage . 1967 . 84 × 76

Annunciation

very important. Can flesh which has neither conquered nor been conquered be glorious?

" Triste fleur qui croît seule et n'a pas d'autre émoi　　"Poor flower that grows alone, experiencing no other thrill
" que son ombre dans l'eau vue avec atonie. "　　"than its shadow seen weakly in the water."

A mirror creates a new sort of distance (how can you grasp yourself on its smooth surface? Your finger would touch your image, not yourself); but into the water that offers one's reflection, one can dive; one can penetrate this lake, enter that river. Soon the body grows more demanding. It must melt into the sea, clasp it, embrace it, let the waves rock it, carry it, take it. The sea is violent and calm—voluptuous. Then comes the time for rest. Perhaps feelings will be soothed. But here the women do not sink heavily into sleep: this face is not really resting on the arm which is bent and lifted back, nor does that other arm stretched alongside the body really droop onto the sheet. The nudes seen from the back, the slow uncoiling of their curves, sometimes a turban on the long hair pulled back remind us of Ingres and his dream-world eroticism. Yet these so precise forms are ready to flee, to slip away from any to possess them. Excitement grows as desire is incessantly aroused and endlessly thwarted. Who are these women who watch over the nude beauty? Some of them are unclothed as well; others are clothed and adorned like the ladies-in-waiting or the mistresses of the robes who used to ornament the antechambers of queens. The resemblance between them prolongs the impression of confusion. The need to get away, the desire to escape burst into this unstable stage between suspenseful calm and anxiety, for desire and its summons are always there. So once again we find the far-off vistas, the roads leading out of sight, the landscapes which, in turn, are multiplied in space and time, the ancient cities very close to the modern suburbs, the enormous mountains on the horizon and, out to sea, great vessels with lofty sails. Perhaps the mere sound of a trolley was enough to crystallize the sudden imperious idea of departure.

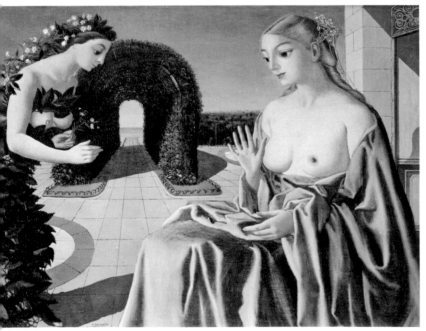

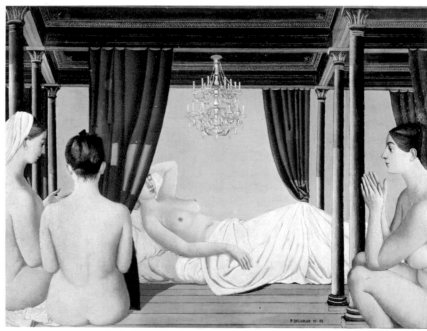

49.

The chandelier . 1952 . 48 × 60.

CRYING TO SEE THESE WOMEN COME

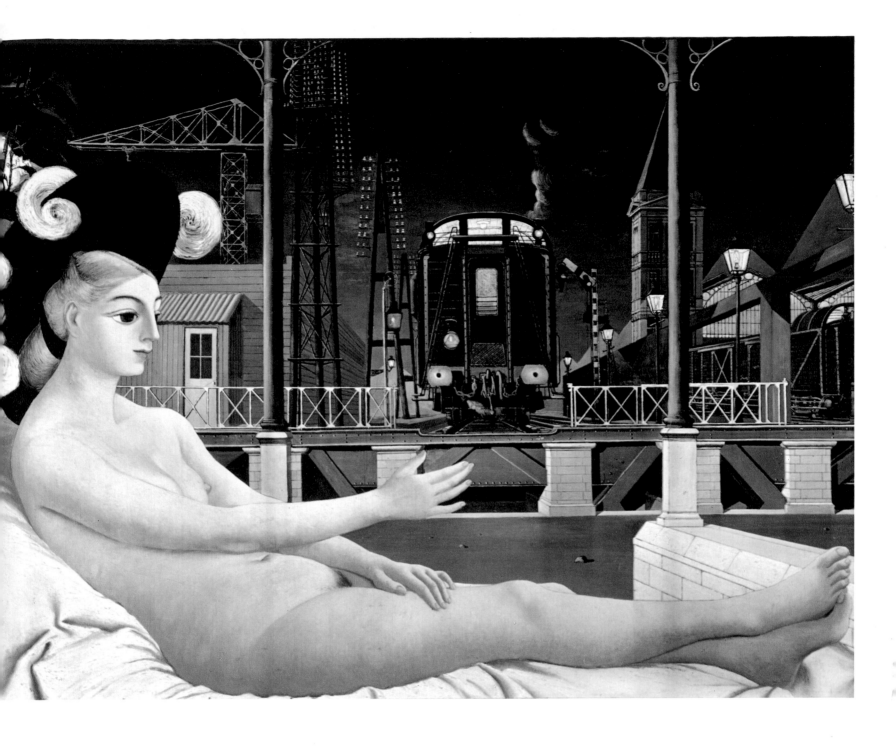

The iron age . 1951 .
61.2 × 97.6

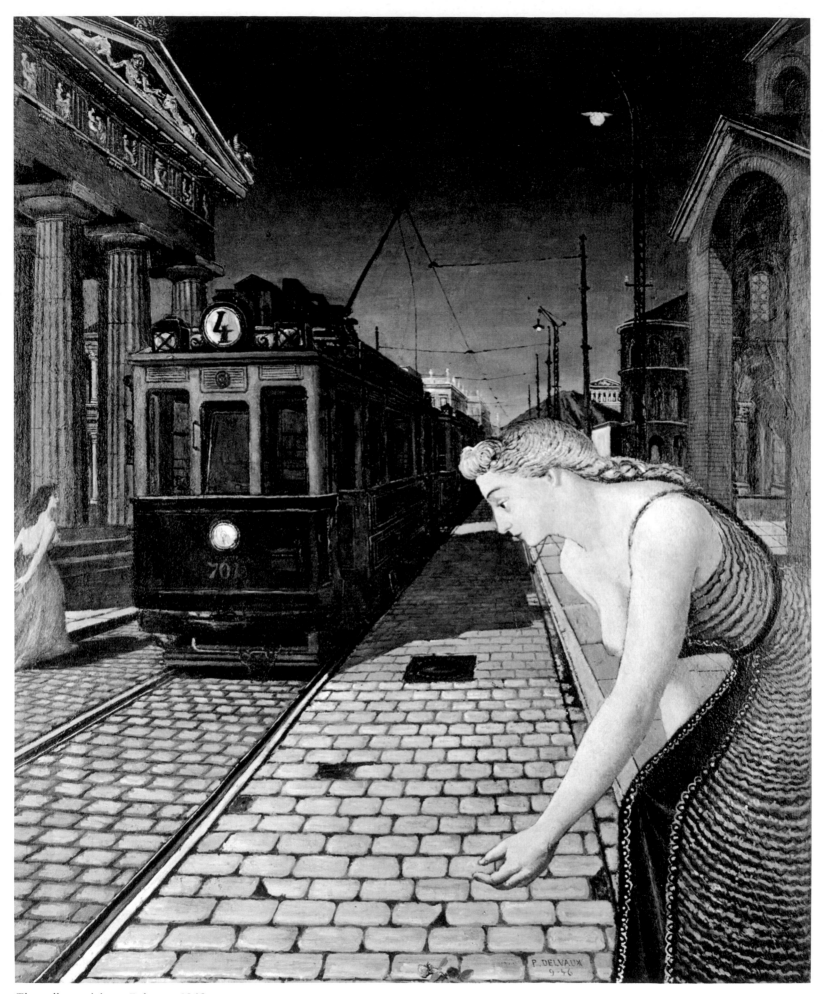

The trolley , red door . Ephesus . 1946 .
33,2 × 25.2
Right : The blue train . 1946 .
48.8 × 97.6

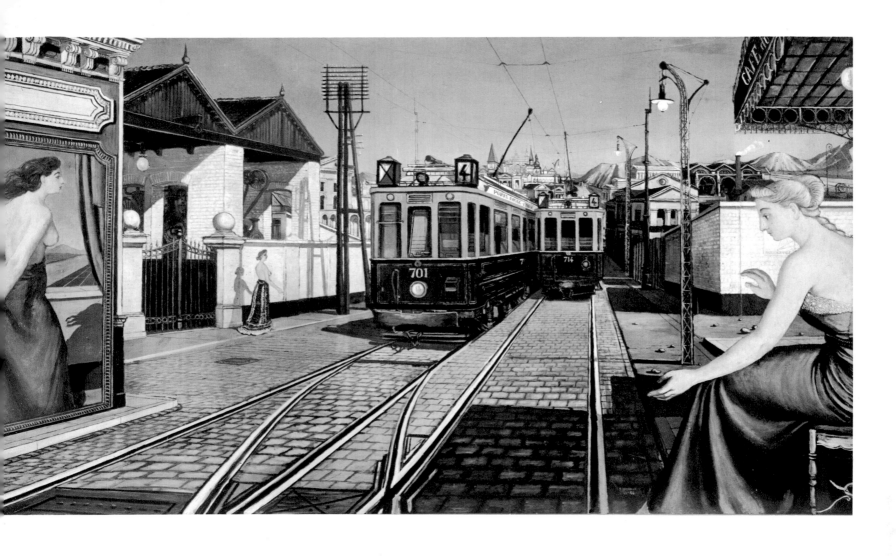

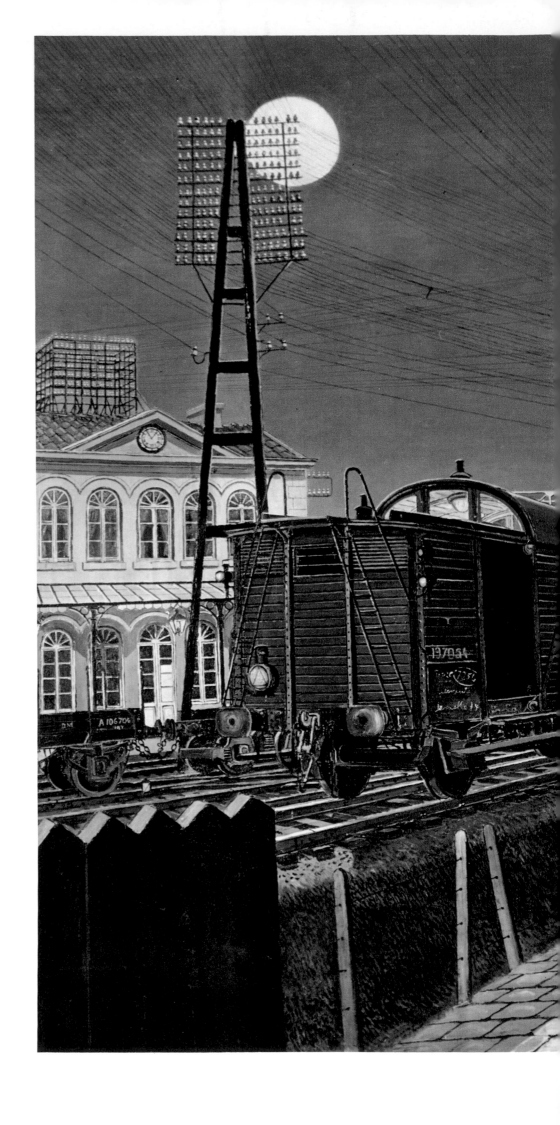

Christmas night . 1956 .
48 × 68

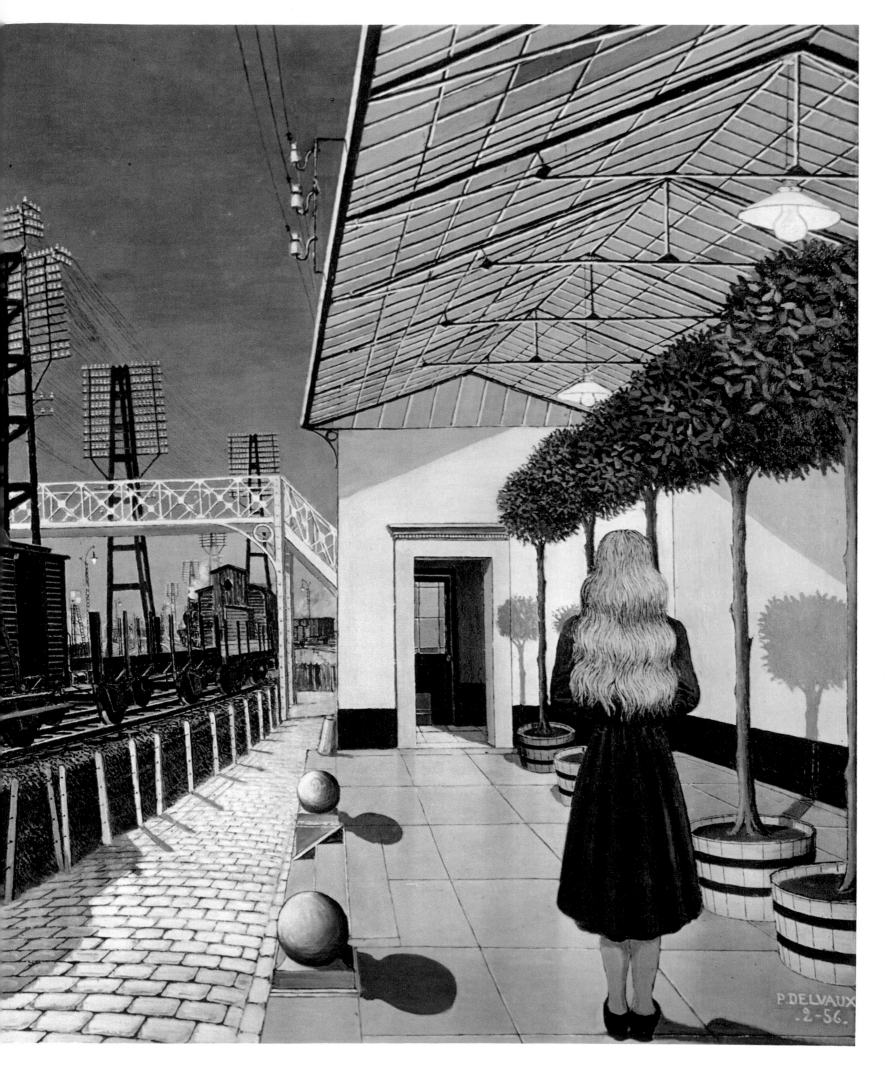

Deep down inside, everyone keeps a set of images of his childhood, and a sound, a smell, a glimpse of some spectacle or other, a wave of regret or nostalgia are enough to bring them into the forefront of his mind. It is only human to yearn to put down roots as deeply as possible, to try to rediscover the roads we have traveled, or follow in our own first footsteps. Rare is the man whose early years do not interest him, or who prefers to overlook them. A whole country of childhood can be revisited which belongs to only a single memory. And so we embark on a quest, finding new solitude, encountering only our own imagination. Over the centuries man, torn between the need to put down roots in one place and the desire to escape to other regions, has invented and perfected means of moving about; the wheel, its power doubled, then multiplied by motors, is the symbol of this. Chariot or carriage, stagecoach or train, all of them have made children dream; take this little boy and this little girl watching the team of horses, then the locomotives and the railway cars, go by. Never is the desire to see and know more compelling than at that age, when the child wants to know everything because he still believes it possible to know everything. What avid eyes! Hence the vividness of a child's first impressions and their forcefulness as memories... To a child, a train is what moves on wheels. Night falls. The lights are turned on; they see; they are eyes. And the signals with their changing colors—red, yellow, green, blue—also move, winking up or down all along the tracks. In addition there are all the noises—wheels on rails, whistles, hiss of escaping steam, bells at railway crossings—that fill the air, that the snow muffles in winter. Later, just one of them will be enough to make the once-upon-a-time child suddenly rediscover this railway landscape, already partly antiquated. The little station comes back to life, its glass-roofed platforms, its porches jutting out onto the square, the figures who people it, its everyday bustle.

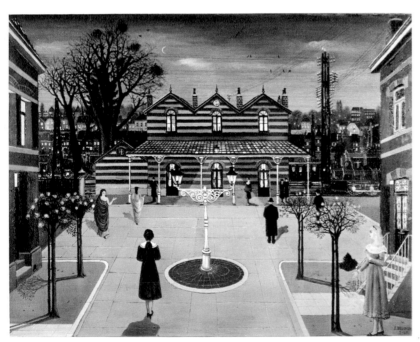

Small square in front of railway station, at dusk . 1963 . 44 × 56

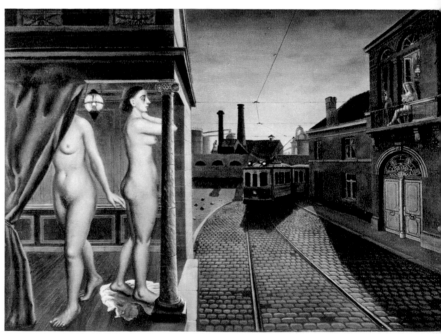

Trolley street . 1938 . 36 × 52

But there are not many travelers this time; sometimes only two little girls or a child standing alone, protected behind the little fence. Nor are all the railway cars coupled yet; their doors are closed.

The locomotive is not puffing in with its trail of smoke; it is standing still alongside the platform.

Usually it is not even visible, merely suggested by a puff of steam in the distance.

The evening trains are lined up on the tracks, among the ware-houses and the sheds, the cab of the baggage car is still lighted—the trains of childhood with every detail intact—the buffers, the high steps, the yellow numbers painted on the green doors. These are not intimidating machine-monsters but miniatures, toys that one loves with that sort of gratitude which, as a child, one had for things.

Delvaux is loyal to them; they are part of daily life, they are necessary; so are these trolleys, and he reproduces the transformations they underwent accurately recorded in his memory. He pays no attention to chronology. His trolleys run in between his temples and structures from classical antiquity, or among the factories and smokestacks. What about these women who dreamed of departures? They stand out before desire, always precise and inaccessible, in the trolley shelter or near the crossing-keeper's little house, or inside the station: will they really go somewhere? The trains pass and do not always stop in front of the waiting rooms... These tall doorways, these series of platforms and tracks with footbridges above them—these are so many disturbing openings onto the uncertain paths of the future. In any departure there is always an unknown factor—hesitation or a change of heart before an impending separation. But all that remains, aside from the haunting creatures of obsession, is the memory of the little train of one's childhood, at a halt before the symmetrical station, white and tidy with its clock, its tile or slate roof, its regularly spaced windows with crossed curtains.

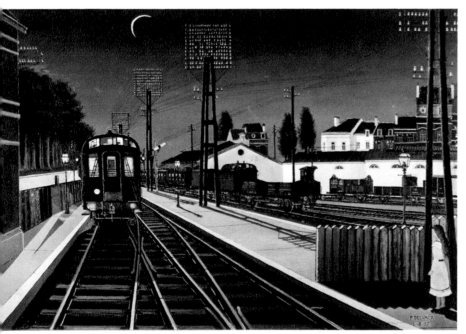

Night trains . 1957 . 44 × 68

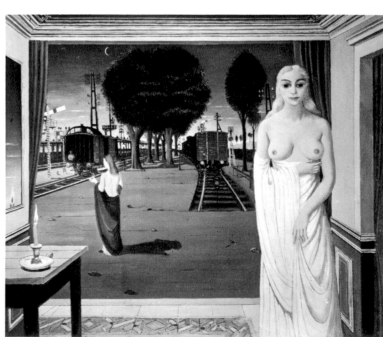

In praise of fire . 1963 . 50 × 60

REIGN
OVER
DEATH

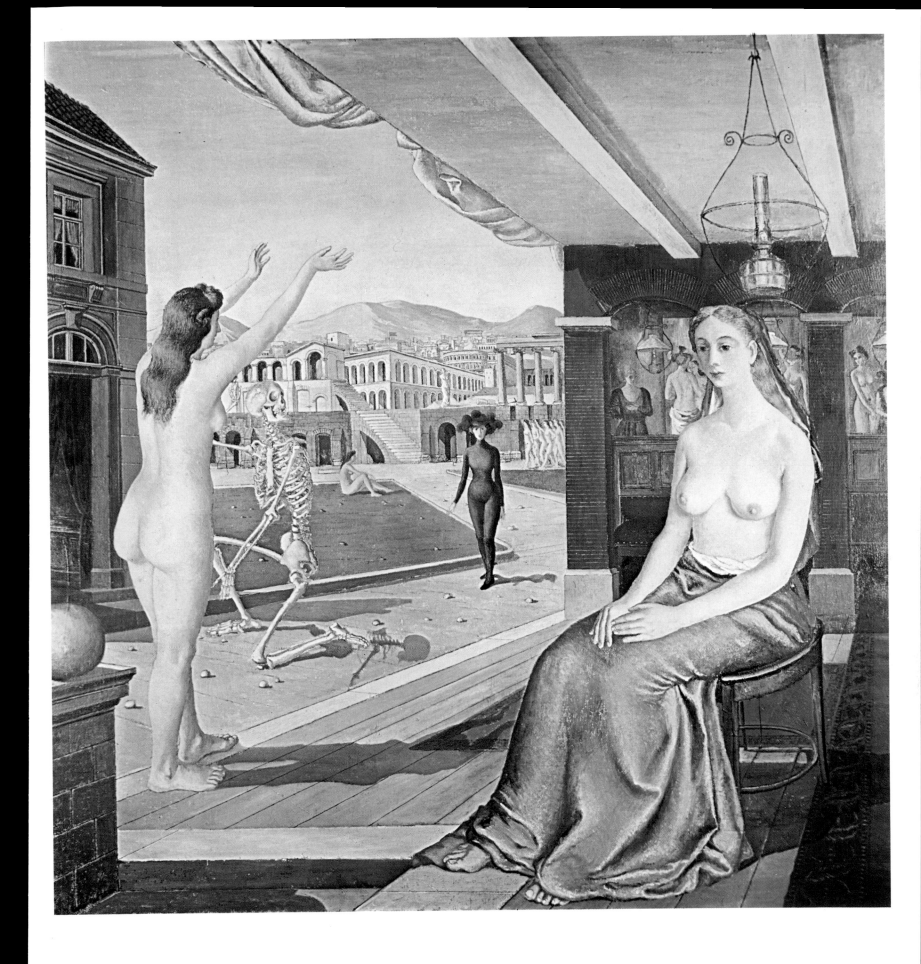

Appeal . 1944 . 62 × 60

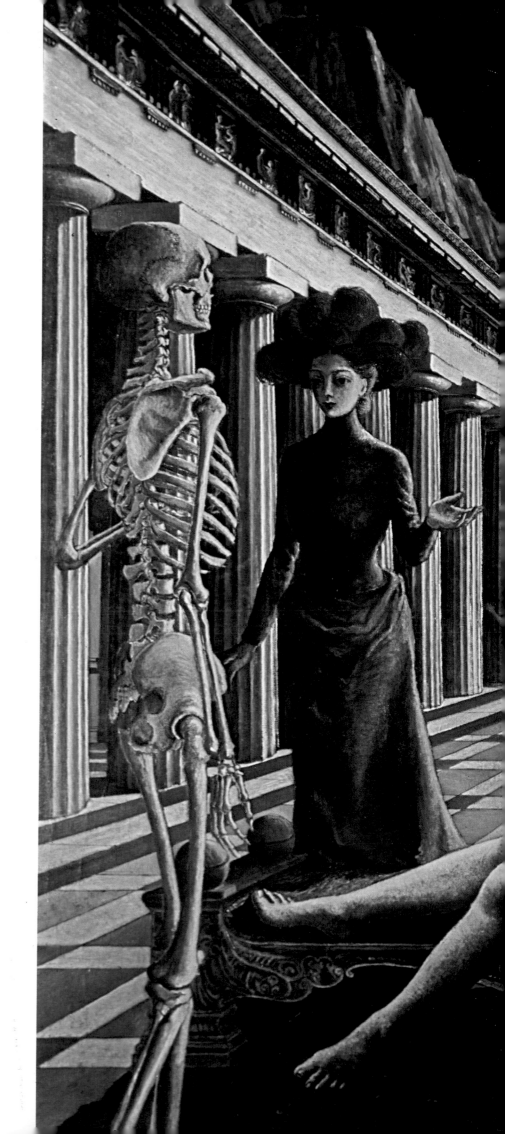

Sleeping Venus . 1944 .
69.2 × 79.6

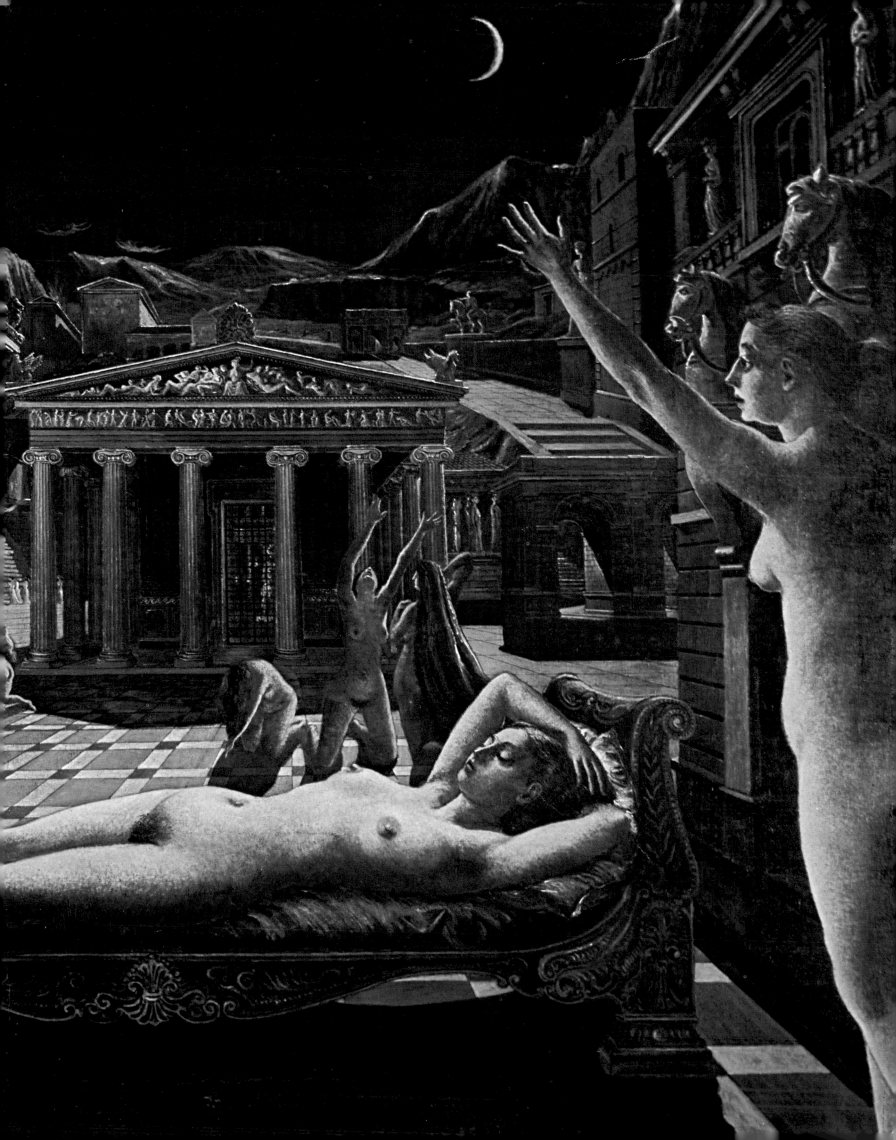

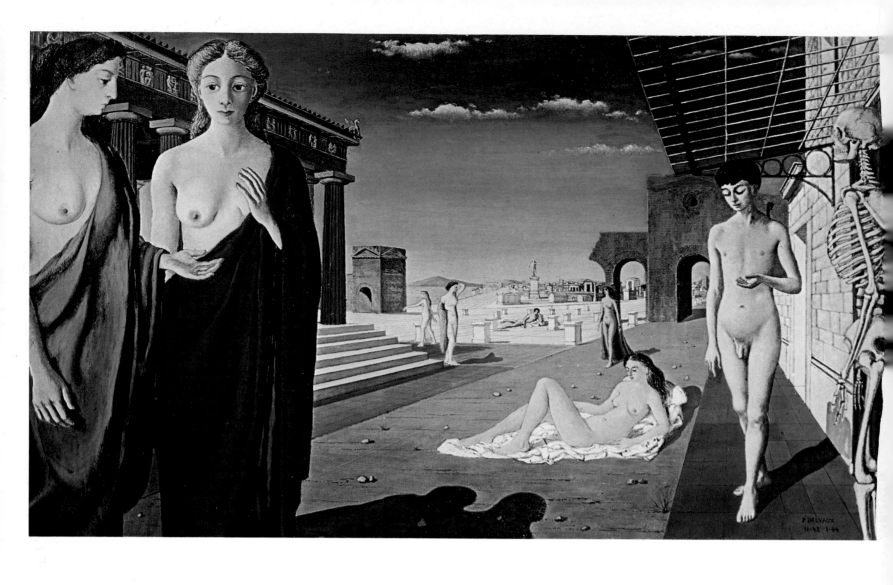

The red city . 1944 .
44 × 72
Right: Spitzner Museum . 1943 .
80 × 96 (detail)

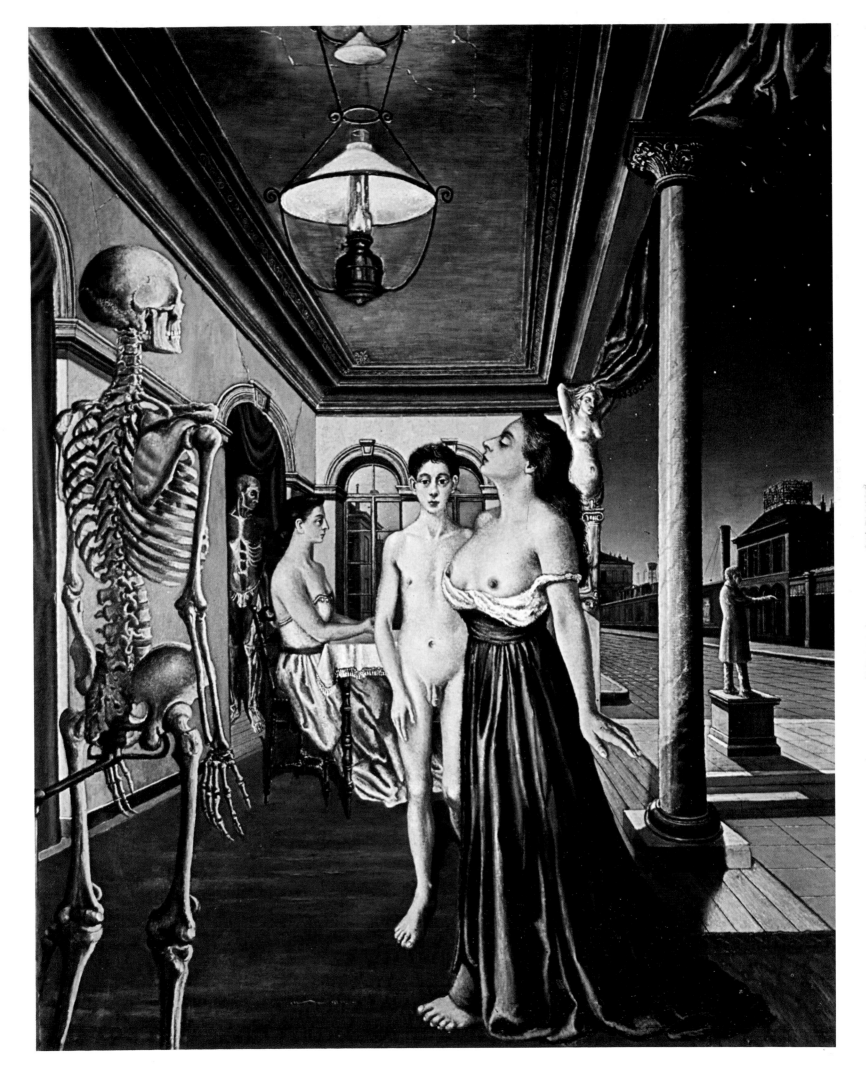

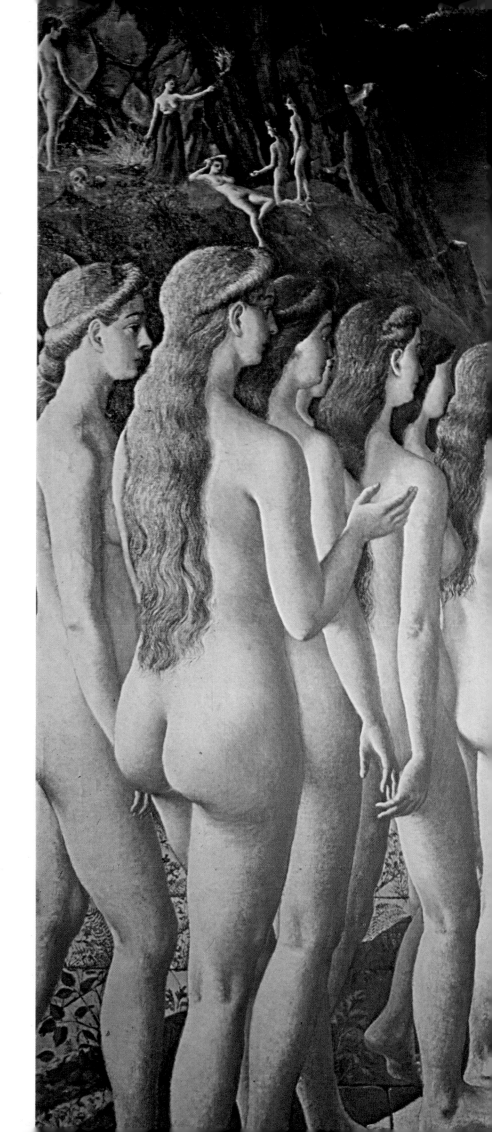

Fire . 1945 . 78 × 92

70

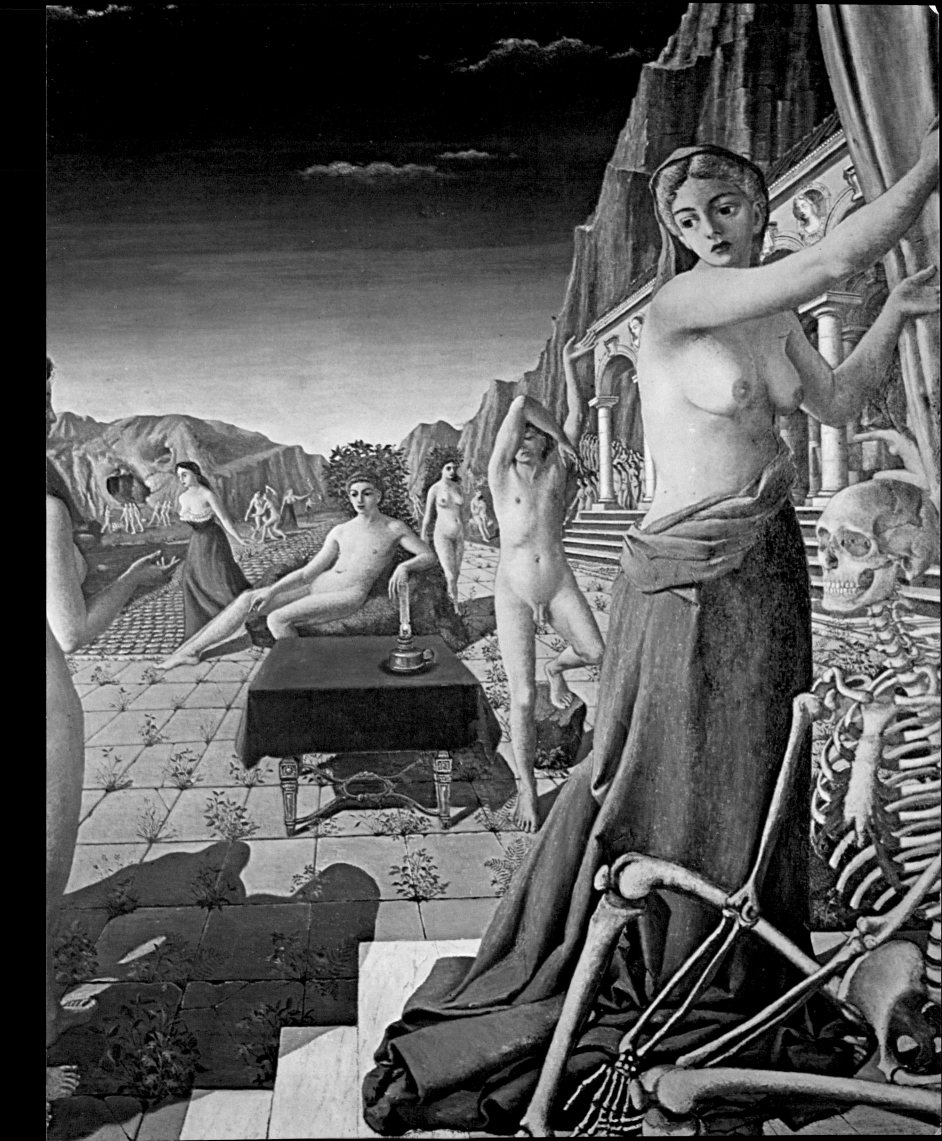

If it is true that all expectation is vain and that man never faces anyone but himself because he cannot really communicate with others; if the questions he asks himself, which are always the same, never find an answer; if therefore man is inexorably alone, is he not continually standing before death? This may explain the repetitions of figures inside Delvaux's works. The same themes, like questions tirelessly asked again and again. And those skeletons, which are not always there just to provide contrast, although that is sometimes their purpose. Of the two—a skeleton, or a bare-breasted woman who seems to be challenging him—which is the more incongruous? The straight lines of tracks—trolley tracks in the city on railway tracks between cities—are also a repetition. Man, creature of habits, lays out a path for himself and goes over it again and again.

At the end of everything there is death, with the feeling of terror and fascination it has always held for men. Hence the different forms in which it is expressed in art, from representation to symbole and allegory. It arouses philosophical meditation—and the painters of "vanities." It creates the absurd... But thinking of death does not mean dying. And a skeleton, as observed in life, is an admirably constructed, perfectly articulated machine. It is the armature, the solid link under the flesh. "What is it about skeletons that strikes you?" Paul Hellyn asked Delvaux. "Their humanness, the feeling that the skeleton is after all the framework of the human being, the living creature...; that underneath his muscles and his face, every living being has a skeleton, and that skeleton is the image of the human being." The precision and finesse of a skeleton incite the painter to nicety of detail in drawing; the strength and lightness of the skeleton make a painter want to animate it. "And from that to wishing to give the skeleton an expression, is not very far: make a skeleton come alive, that is endow it with life, make it walk and talk, make it make gestures

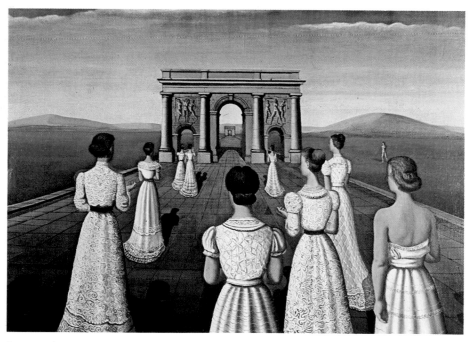

Lace cortège . 1936 . 46 × 64

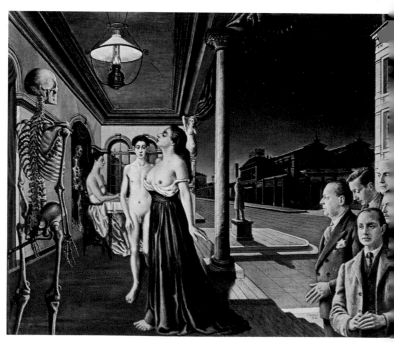

Spitzner Museum . 1943 . 80 × 96

like a living creature. It think that can be done. I didn't want to represent death. That wasn't my idea at all. I wanted to do scenes of expressive skeletons." Which accounts for the way he insists, so to speak, on the sequence of movements. Through an odd reversal, Delvaux's skeletons become more animated and expressive than his flesh-and-blood figures, whose uneasiness always stems from one context. But even though the artist ultimately found that skeletons have "great beauty," nonetheless they did originate in a moment of fright, when the child discovered them in a museum; in him, they became "obsessive images." And we cannot entirely escape from the horror produced by this wholly disembodied body.

Reminiscence of the medieval "danse macabre" assail us before these paintings, where a passerby, a richly clothed woman, comes suddenly face to face with what our atavism makes us a view as a representation of death, ready to embrace her. Little does it matter that there is, again, a nude woman lying in the center of the canvas, or another whose arm is raised in a gesture of appeal. Appeal to whom?

A feeling of ridiculousness surges in our minds.

Already, the shells and the bone fragments often visible in Delvaux's landscapes seemed to restore this world to an infinitely remote age, a sort of elusive previous life. They were enough to give a feeling of distance, like these antique temples next to modern factories, like these old-fashioned trains and stations, so near and yet so far. "There was something to be derived from this void, this mystery..." Delvaux does not confer a meaning upon that distance. First of all, he felt it as a painter, the way a musician hears the First of all, he felt it as a painter, the way a musician hears the silence.

Then it became transformed within him, releasing images. What he transmits is an expression of that distance, somewhere in between absurdity and dream. "Creating poetry," he remarks, "by painting."

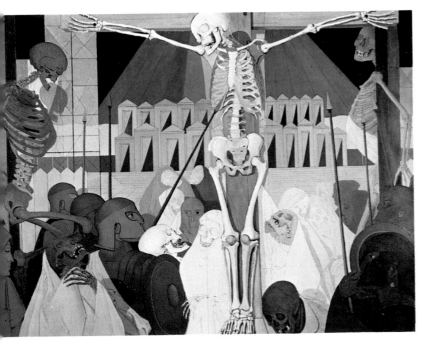

Crucifixion II . 1954 . 80 × 108

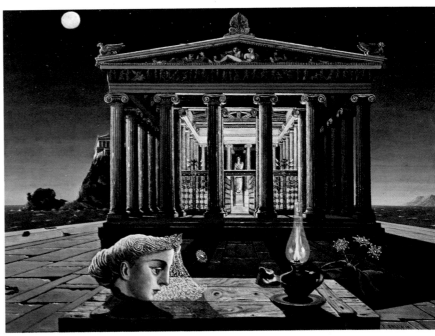

The temple . 1949 . 44 × 57.2

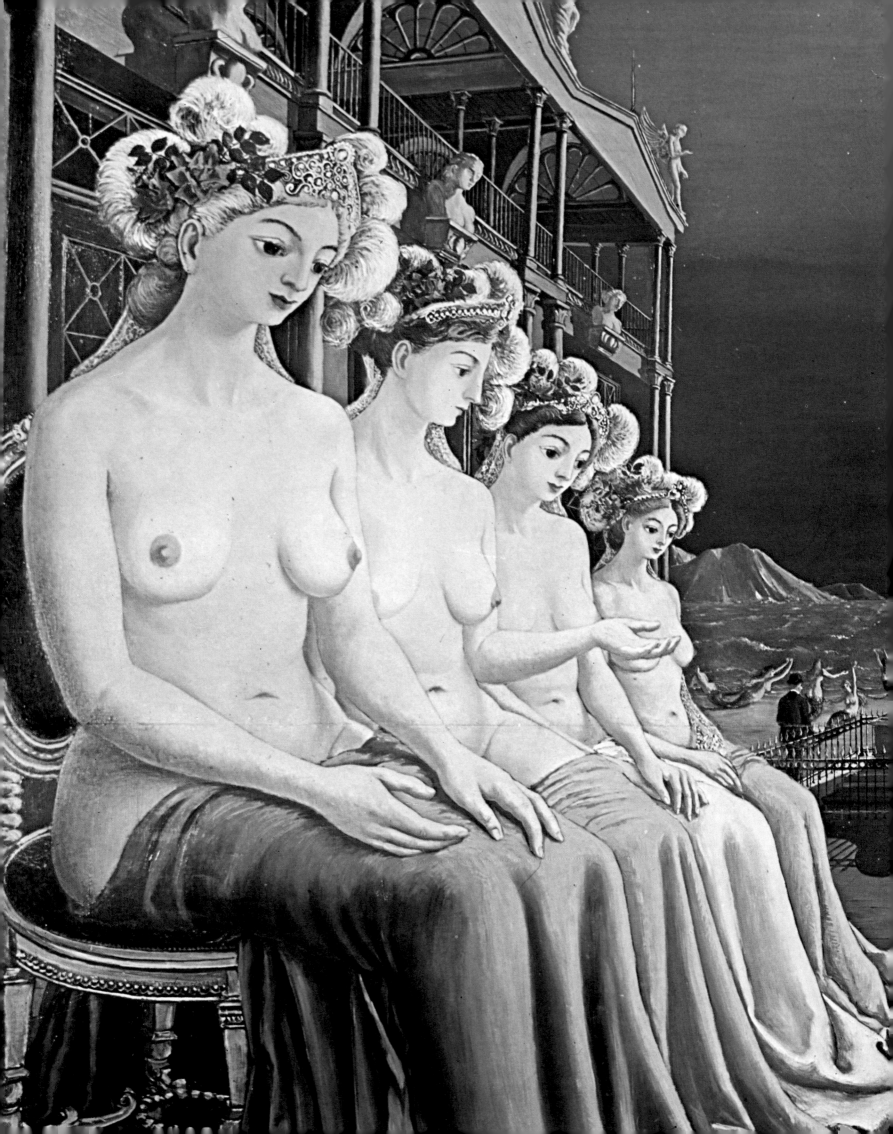

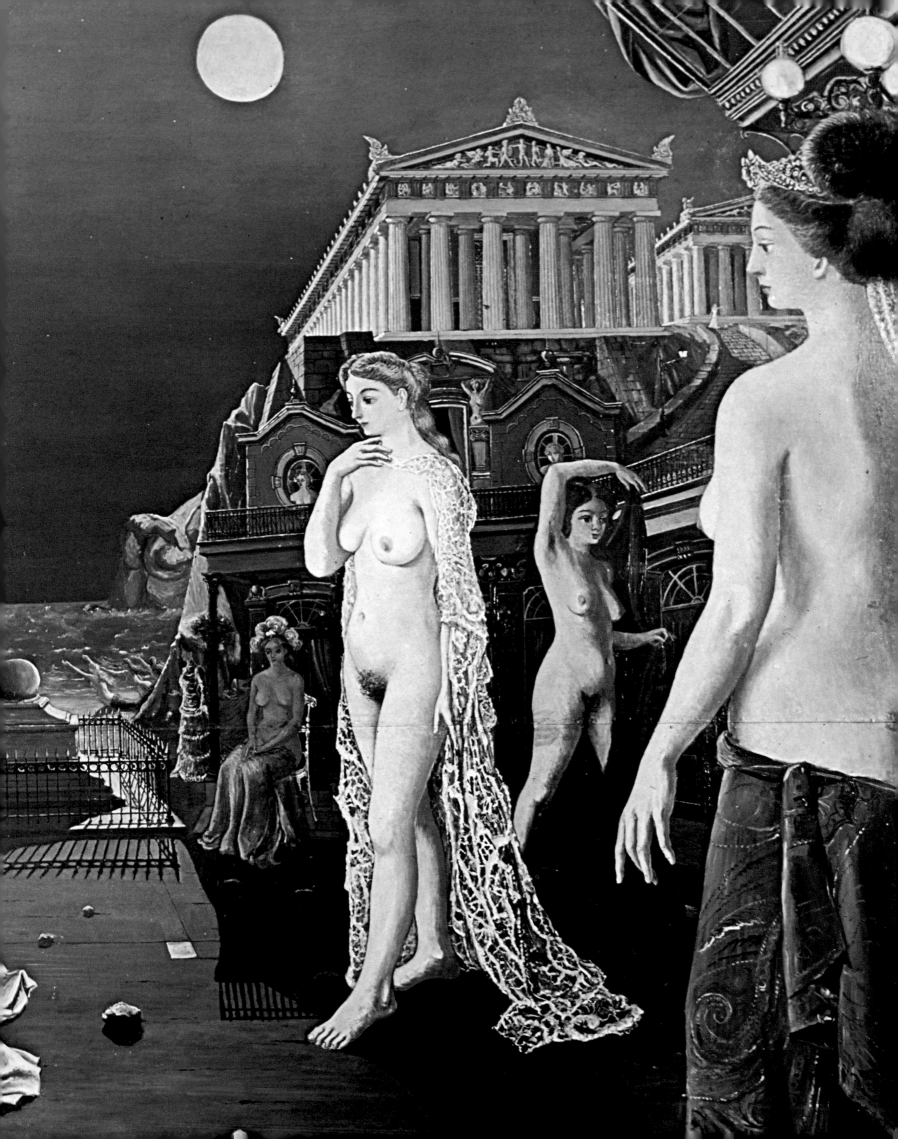

Livréés à leur destin ne rien

connaître qu'elles-mêmes.

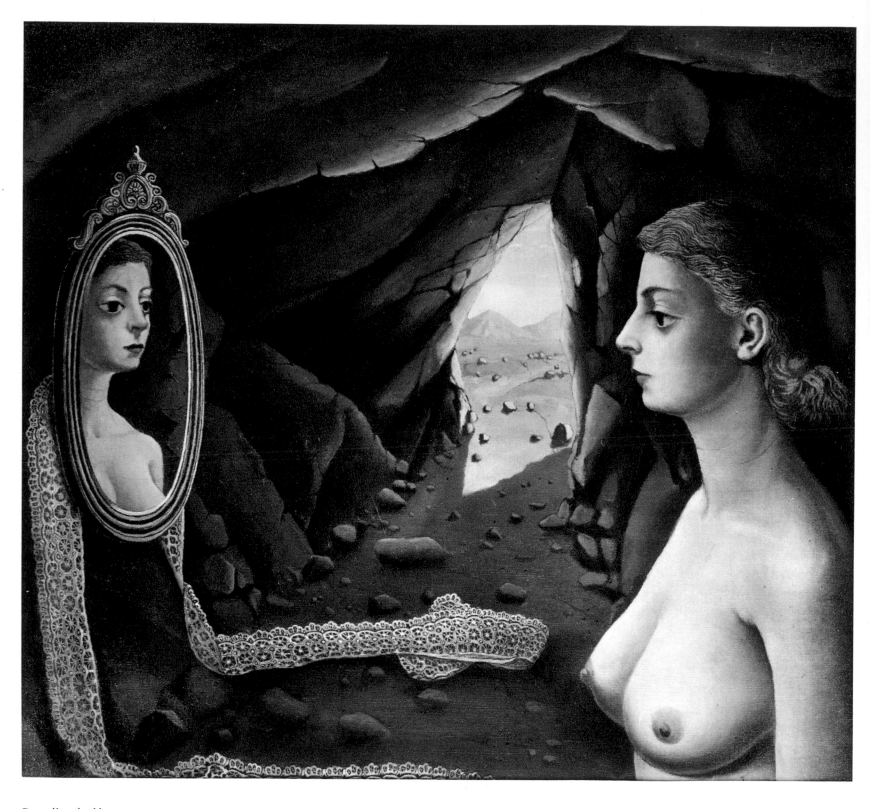

Preceding double page :
The tall mermaids . 1947 .
81.2 × 122

Above :
Woman at her mirror . 1936 .
42 × 52

BIOGRAPHY

1897: Paul Delvaux is born on 23 September at Antheit, near Huy (Belgium). Childhood and classical studies in Brussels, where his father is a lawyer. Vacations spent at Antheit and Wange.

1919: The painter Frans Courtens encourages him to paint.

1920-1924: Studies at the Brussels Academy of Fine Arts.

1930: Expressionist painting important for him. Is struck by Permeke and Gustave de Smet especially; admires James Ensor.

1932: A visit to the Spitzner Museum booth at the Brussels Fair impresses him deeply.

1933: Exhibits at the Atelier de la Grosse-Tour, in Brussels.

1934: Minotaur exhibition at the Palais des beaux-arts in Brussels. Magritte and, above all, Chirico are a revelation; he discovers himself.

1938: Takes part in the international Surrealist exhibition in Paris. Paul Eluard dedicates his poem, "Exil," to him. First trip to Italy.

1940: Takes part in the international Surrealist exibition in Mexico City.

1944: Retrospective at the Palais des beaux-arts in Brussels.

1948: Retrospective at the Drouin gallery in Paris.

1950-1962: Professor at the Ecole nationale supérieure d'art et d'architecture in Brussels.

1965: Member of the Royal Academy of Belgium, then Director of its Chair of Fine Arts.

1968: A room at the Belgian pavilion of the 34th Venice Biennale is set aside as a tribute to him.

1969: Retrospective at the Musée des Arts Décoratifs in Paris.

BIBLIOGRAPHY

1945 René Gaffe, **Paul Delvaux ou les rêves éveillés.** La Boétie, Brussels.

1948 Claude Spaak, **Paul Delvaux.** De Sikkel, Antwerp.

1949 Emile Langui, **Paul Delvaux.** Alficri, Venice.

1965 Paul-Aloïse De Bock, **Paul Delvaux.** Johannes Asmus Verlag, Hamburg.

1967 Paul-Aloïse De Bock, **Paul Delvaux.** Laconti, Brussels.

1967 Alex Grall, **Les Dessins de Paul Delvaux.** Denoël, Paris.

FILMOGRAPHY

1948 Henri Storck, **Le monde de Paul Delvaux.**

1952 E. Tack and P. Faniel, **Quatre peintres belges au travail.**

1967 P. Danblon and A. Denis, **Le monde intérieur de Paul Delvaux.**

Some particularly interesting interviews with Delvaux have been recorded by Paul Hellyn (1954-1965) and Anne Bodart (1961).

We wish to thank the collectors and museums who gave us their kind assistance, including: Mr. Joachim Jean Aberbach, New York; Mr. Julian J. Aberbach, New York; Mr. J. P. Amoore, Paris; Mr. Marcel Baugniet, Mr. and Mrs. Robert M. Benjamin, New York; Dr. Blavier, Liège; Mr. Gaston Durssens, Ghent; Crédit communal de Belgique, Brussels; Mr. Debra, Veurne; Mr. A. Delvaux, Museum voor Schoone Kunsten; Dr. O. Demol, Brussels; Mr. J.E. Flagey, Brussels; "Le Bateau Lavoir" Gallery, Paris, Mr. J. Giron; Mr. Janlet, Brussels; Mr. Kriwin; Mr. Mabille, Brussels; Mr. and Mrs. Micha, Brussels; Musée d'Art wallon, Liège; Musée des beaux-arts de Charleroi, Charleroi; Museum of Modern Art, New York; Mr. Gustave J. Nellens, Casino de Knokke; Dr. Robert, Brussels; Mrs Robiliart, Brussels; Mr. P. Salik, Brussels; Société des expositions du Palais des beaux-arts, Brussels; Mr. J.L. Stern, New York; Dr. Tagnon, Brussels; Mr. G. Van Geluwe, Brussels; Mr. P. Willems, Brussels.

The photographs are by Jean-Pierre Lebert and X...
The measurements of all works illustrated in this volume are given in inches; height precedes width.
The poem entitled "Exil" by Paul Eluard is taken from **Œuvres complètes de Paul Eluard**, Bibliothèque de la Pléïade, Tome I, "Donner à voir," published by Gallimard, Paris, 1968.
Lay out : Jacques Segard.